IMAGES
of America

McLean

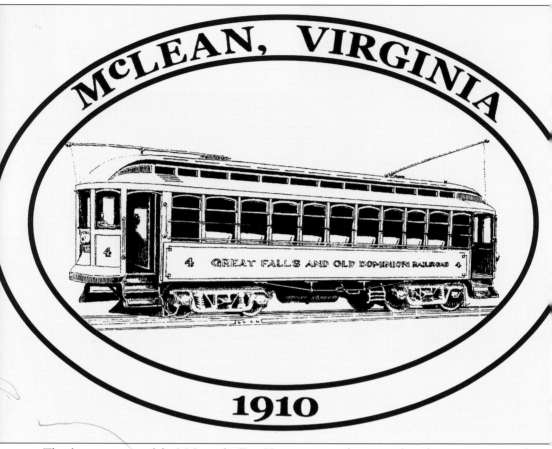

This logo was created for McLean by Eric Hottenstein and presented to the community at the McLean Centennial Celebration in June 2010.

ON THE COVER: This is a photograph of McLean's main intersection, Chain Bridge Road and Old Dominion Drive, taken in the late 1950s. (Fairfax County Public Library Photographic Archive.)

IMAGES
of America

McLean

Carole L. Herrick

ARCADIA
PUBLISHING

Published by Arcadia Publishing
Charleston, South Carolina

Printed in the United States of America

Library of Congress Control Number: 2010937265

For all general information, please contact Arcadia Publishing:
Telephone 843-853-2070
Fax 843-853-0044
E-mail sales@arcadiapublishing.com
For customer service and orders:
Toll-Free 1-888-313-2665

Visit us on the Internet at www.arcadiapublishing.com

To Vincent Callahan Jr. who served 40 years in Virginia's House of Delegates representing McLean and other communities within his district.

CONTENTS

ACKNOWLEDGMENTS

One of the joys in finishing any book is the opportunity to thank the many individuals who helped with the project. The story of McLean could not have been produced without the support and patient editing of Mary Anne Hampton and Page Shelp, whose knowledge of McLean brings life to the book. This is as much their book as mine, even though their names do not appear on the cover. The staff at the Virginia Room, a part of the Fairfax County Public Library system, was extremely helpful in gathering photographs. In particular I would like to thank Suzanne Levy, Elaine McHale, Kathe Gunter, and former staff persons Susan Hellman, Karen Moore, and Sandy Lewis. I am also grateful for the guidance provided by Tom Jacobi and his skilled assistants, Kris Muten, Kai Muten, and Chris Muller, at Langley Photo and Digital.

A grateful acknowledgment is likewise due to the following individuals: Sabrina Anwah, David Bettwy, Elaine Strawser Cherry, Anna Eberly, Bob Eldridge, Philip Graves, Ann Hennings, Jerry Hennings, Charles Herrick, Lynne Garvey-Hodge, Caroline Hottenstein, Eric Hottenstein, Homer Johns, Annabelle Knauss Rhinehart, Paul McCray, Virginia McGavin Rita, Sylvia Knauss Sterling, Dariel Knauss VanWagoner, and Ed Wenzel.

INTRODUCTION

A community is not complete unless it has a written history of its own. The present is always linked to the past and things are the way they are for a reason. Few states have had more written about their history or historic sites than Virginia, yet the Northern Virginia area adjacent to the Potomac River known as McLean has virtually been ignored. The community has never produced a comprehensive history detailing its magnificent past. Through photographs, this book is an attempt to do just that. Some of the early historical figures entwined with the history of what became McLean include Capt. John Smith, Thomas Lee, Henry "Light Horse Harry" Lee, George Washington, James Madison, Dolley Madison, James Monroe, Thomas ap Catseby Jones, Thaddeus Lowe, Gen. William ("Baldy") Smith, and Gen. George McClellan. Other well-known personalities that later influenced the McLean community were John McLean, Supreme Court Justice Robert Jackson, Sen. (later president) John Kennedy, Jacqueline Bouvier Kennedy Onassis, and Robert Kennedy. In this work, an attempt has been made to place events in chronological order so that the reader can visualize the growth and change that has taken place over the years.

McLean is just a stone's throw from the nation's capital, with much of the area spreading along the palisades of the Potomac River. To those unfamiliar with the area, the location may suggest a colonial style atmosphere with narrow cobbled stone streets, restored buildings, antique shops, and old wharves with boats along the river. To others, the name may imply a Palm Beach or Beverly Hills (Rodeo Drive) type atmosphere with gleaming shops supporting designer names. McLean is neither of the two. It is simply a community that sporadically developed around a trolley stop of the Great Falls and Old Dominion Railroad at Chain Bridge Road, a major thoroughfare in Fairfax County since colonial times. This was an electrified railroad that ran from Rosslyn to Great Falls Park, linking with the District of Columbia via the old Aqueduct Bridge. The railroad first carried passengers into Great Falls Park on July 4, 1906. The line bypassed the existing villages of Langley and Lewinsville. Instead, land was purchased for a straighter right-of-way and the tracks were laid through forests, farmland, and fruit orchards about midway between the two villages.

Originally the stop at Chain Bridge Road was called Ingleside after a community that was beginning to develop along Elm and Poplar Streets. However, by 1910, the Ingleside name had changed to McLean, to honor one of the trolley's founders, John R. McLean, who was also the publisher of the *Washington Post* and *Cincinnati Enquirer* newspapers; and so, the next stop down the line, to the west, became known as Ingleside. Stephen Elkins, a senator from West Virginia, was the other founder of the railroad, and the stop at Georgetown Pike, another major transportation avenue in the county, was called Elkins Station. The trolley was strictly a business venture designed to promote the beauty of the Great Falls. McLean and Elkins had no intention of developing the area along the route.

In 1908, Mary and James Raeburn opened a general store beside the tracks facing Chain Bridge Road. Unfortunately they were not adept entrepreneurs and found themselves shortly thereafter facing foreclosure. Their property, including the store, was sold at auction on April 5, 1910, to

John Storm, a prosperous local dairy farmer. In June of that year, one of his sons, Henry Alonzo Storm, opened Storm's General Store, from which the McLean Post Office operated. The day that Storm opened his general store is considered the beginning of McLean. There was no celebration. The "town" was not founded and it was never incorporated. It's doubtful that John McLean ever set foot on turf at the McLean stop.

An amorphous village began to slowly develop in a hodgepodge fashion, with Storm's Store the nucleus of the community. By the mid-1920s, McLean had grown to be more than just a stop on the rail line; it was a thriving community. The village consisted of the Franklin Sherman School (the first public consolidated school in Fairfax County) and it had its own fire station occupied by the McLean Volunteer Department, which incorporated in 1923 as Station No. 1 in Fairfax County. It also had two churches, the Sharon Masonic Temple, a library, a civic association, a four-bay strip mall, and a real estate office. McLean Day, the first event of its kind in the county, was held annually to raise money for the school and fire department. On the fringe of the village was West McLean, an area of residential houses that was beginning to develop. Extraordinary farms, such as Sharon, Kenilworth, Spring Hill, Maplewood, Prospect Hill, Heath, and Carper surrounded "McLean proper," and there were magnificent estates that included Ballantrae, Hickory Hill, and the Leiter Mansion. Little thought was given to a nondescript spot two intersections down the road past Maplewood, known as Tysons Crossroads; this was the junction of Chain Bridge Road and Leesburg Pike, two major transportation arteries in Fairfax County.

The Great Falls and Old Dominion Railroad operated for 28 years. By the early 1930s, there was a substantial decline in riders. People were beginning to take fewer Sunday excursions to the park, but most of its demise is attributed to the rise of the Model T. The last run of the trolley was on June 8, 1934, and its tracks were removed the following year. The roadbed was later paved with asphalt and became Old Dominion Drive.

McLean remained a farming community and did not change significantly between the mid-1920s and the end of World War II. However, after the war, many veterans, military personnel, and government employees decided to remain in the greater Washington metropolitan area, stimulating the construction of numerous, affordable, single-family homes in the suburbs. The growth that began in McLean at that time, along with the CIA locating to Langley in 1961, can easily be seen through the dramatic increase in area churches, schools, houses, new highways, and mini strip malls, all at the expense of the orchards and farms. Yet, with the increased population and expansion, the village of McLean did not change all that much and maintained its rural community atmosphere.

About this time, a "sleeping giant" awoke at the nondescript intersection on the periphery of McLean, and McLean suddenly found itself overshadowed by Tysons Corner, one of the largest office and retail centers in the United States. The first of two enclosed malls, Tysons I, opened in 1968 and the Tysons area kept growing. Today it is considered to be the downtown of Fairfax County: it holds one-fourth of the office space and one-eighth of the retail space in the county, and it is poised to become much larger. With the urbanization and continual expansion of Tysons Corner, and with the new Metrorail service being put in place there, one has to wonder about the future of the village of McLean. Will it go the way of Lewinsville or Langley? Hopefully this will not be the case and the community will not lose its identity, or get gobbled up in the enthusiasm of progress.

One

THE BEGINNING

Everyone has a general knowledge that in 1607, Capt. John Smith landed at Jamestown, the first permanent English settlement in America. Most are not aware that Smith, with a crew of 14, surveyed the Chesapeake Bay the following summer and sailed up the Potomac River. The group reached the head of navigation at Little Falls, just above today's Chain Bridge, before returning to the bay.

Forty-one years after Smith's voyage, King Charles II rewarded seven English noblemen with 5 million acres in Virginia. This became the Northern Neck Proprietary, later called the Fairfax Proprietary. Early settlement in the proprietary was steady, but few pioneers were adventuresome enough to brave settling the wilderness along the upper Potomac until Gov. Alexander Spotswood negotiated the Treaty of Albany with the Iroquois League of Six Nations in 1722. This treaty mandated that the Iroquois remain west of the Blue Ridge Mountains and on the Maryland side of the Potomac.

However, a few Europeans were acquiring property along the upper Potomac before the Treaty of Albany. One such individual was Thomas Lee, who, after serving as resident agent for Lady Catherine Fairfax, was able to make use of his knowledge and acquired a great deal of land. Among his acquisitions was a 1719 grant of 2,862 acres near Little Falls, which he named Langley after ancestral holdings in Shropshire, England. In 1748, Lee was granted a license to establish a tobacco warehouse landing below Little Falls at the mouth of Pimmit Run.

The tobacco operation never developed into the enterprise Lee envisioned. But the site was significant for the future of McLean. The Little Falls Bridge (Chain Bridge), the first bridge spanning the Potomac, connected Virginia with the District of Columbia at this location in 1797, and the existing road that led from the bridge became a major thoroughfare winding south through Fairfax County. McLean was able to develop into a community at a stop of the Great Falls and Old Dominion Railroad because of its location on Chain Bridge Road.

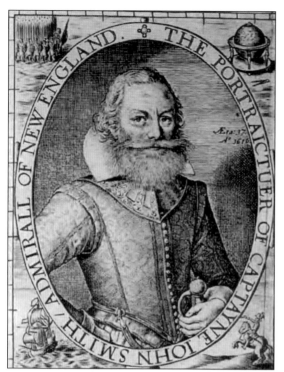

On June 2, 1608, John Smith and a small crew left Jamestown on the first of two voyages to explore the Chesapeake Bay. Their barge entered the Potomac River on June 16 and stopped at several Indian villages, both hostile and friendly, before reaching the head of navigation at Little Falls on June 24. This was the first group of Englishmen to visit the Northern Virginia area. (Virginia State Library.)

Smith, along with Nathaniel Powell, a member of the second voyage, incorporated the survey of the Chesapeake Bay into a map of Virginia. Considering that Smith's only navigation instruments were probably a compass for direction and a quadrant for measuring the sun's angle, their map of the bay and its inhabitants was amazingly accurate. The engraving below was published in 1624. (Library of Congress.)

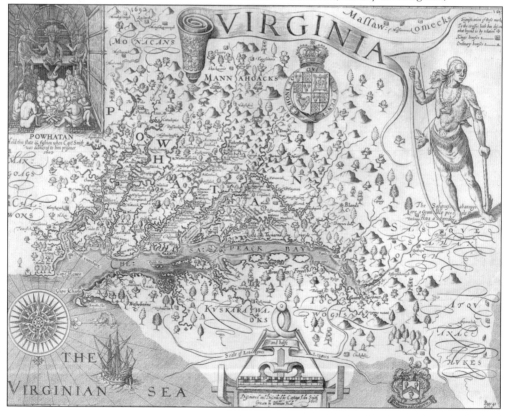

In 1689, Catherine Culpeper received title to a five-sixths portion of the Northern Neck Proprietary upon the death of her father, Thomas, Second Lord Culpeper; her mother, Margaret Lady Culpeper, held the remaining one-sixth. The following year Catherine, shown above, married Thomas, Fifth Lord Fairfax of Cameron, who managed her interest in the proprietary. By this marriage the Fairfax family acquired the Northern Neck Proprietary. Lord Fairfax managed his wife's interest in the proprietary as if it was his own and he reconfirmed the patent by Order in Council in 1694. Lord Fairfax died in 1709 and again, for a brief period of time, the two Culpeper women owned and managed the proprietary. Eventually, the one-sixth share was inherited by Thomas Sixth Lord Fairfax upon the death of his grandmother in 1710 and, after the death of his mother, Lady Catherine Fairfax, in 1719, he received the remaining five shares. (Fairfax County Public Library Photographic Archive.)

In 1728, Robert "King" Carter (left) formed the Frying Pan Company, believing that copper was abundant in the Frying Pan Branch of Broad Run. For shipping purposes Carter planned on building a road from the mine to an ore dock near Little Falls. However, before Carter's papers were filed, Thomas Lee (below), envisioning commercial tobacco operations along the Potomac, patented an additional 146 acres at Little Falls. Carter was forced to find another route to transport ore from the mine to English ships. The copper was of poor quality and the mining operation lasted less than four years. Lee was granted a license in 1742 to establish his tobacco landing near the Little Falls. Philip Ludwell Lee inherited the site in 1750. He maintained the tobacco operation and incorporated a never-realized town named Philee. The Little Falls venture was never successful, but its location was significant for the future villages of Langley, Lewinsville, and later McLean. (Left, Fairfax County Office of Planning and Zoning; below, Stratford Hall, Robert E. Lee Memorial Association.)

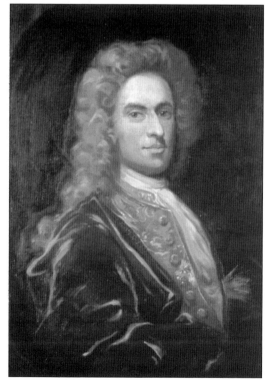

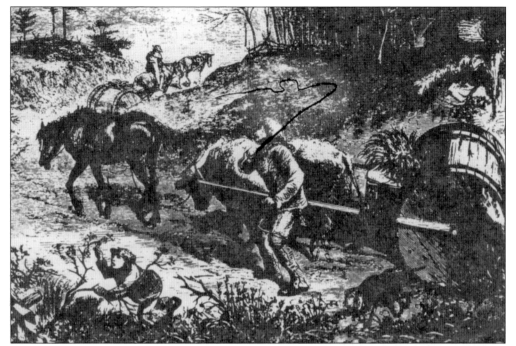

Tobacco dominated the lives of the early colonists. As it exhausted the Tidewater land, planters moved further inland. Rolling roads came into existence. These were roads over which hogsheads filled with tobacco were "rolled" from upriver plantations to warehouses and inspection stations, then transported by ship to England. These hogsheads were fitted with axles and shafts to which oxen or horses were harnessed, as shown above. (Library of Congress.)

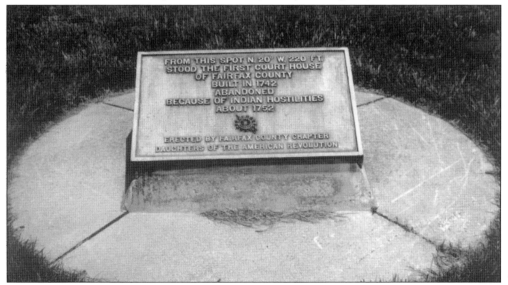

As population increased during the 18th century, Virginia's General Assembly created parishes, which preceded the formation of a county. Truro Parish formed in 1732 and became Fairfax County on June 19, 1742. The photograph shows a small monument at the northeast corner of Old Courthouse and Chain Bridge Roads marking the location of Fairfax County's first courthouse. (McLean & Great Falls Celebrate Virginia.)

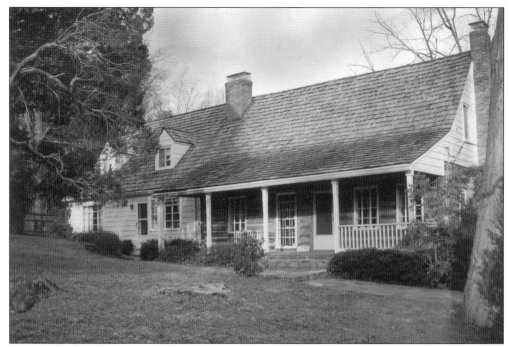

Thomas Lewis was deeded 633 acres in 1725 along Difficult Run where he built a log cabin. James Oliver purchased the house and part of the land in 1836, and established a family cemetery nearby. Temple Smith later inherited the property. Beginning in 1940, additions were made to the log house, while retaining its rustic appearance. The Henry Mackalls purchased the house in 1958 and added further improvements. (Susan Hellman.)

A one-room log cabin that became known as the Dower House was built c. 1722. It was burned by Federal troops during the Civil War. Part of the house was saved and later rebuilt. In 1920 it was covered with clapboard, followed by modernization and many additions. The house remains on Georgetown Pike and the dining room may be the original log cabin. (Fairfax County Public Library Photographic Archive.)

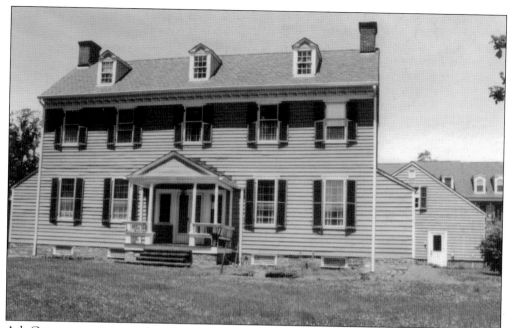

Ash Grove was constructed on the site of a hunting lodge built *c.* 1750 by Bryan Fairfax, Eighth Lord Fairfax. His son, Thomas, who renounced the title Ninth Lord Fairfax, built the major portion of the house *c.* 1790. The house, plus two small outbuildings, remains in the eastern section of the Tysons Corner area surrounded by townhouses. (McLean & Great Falls Celebrate Virginia.)

The Hitchcock Toll House once stood on the Alexandria-Leesburg Turnpike across from today's Andrew Chapel United Methodist Church. When Leesburg Pike was widened during the late 1960s, the house was moved to a location in Woodside Estates. It was discovered that two log sections underneath the clapboard siding were held together by wrought iron straps. One section was built *c.* 1750; the other dates to *c.* 1790. (McLean & Great Falls Celebrate Virginia.)

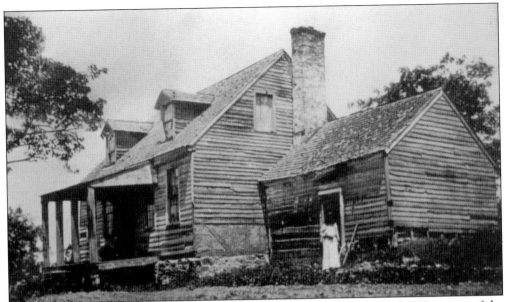

Towlston Grange, named after a Fairfax estate in England, was built around 1767 on part of the 5,568-acre Towlston tract. It was a frontier home for Bryan Fairfax, Eighth Lord Fairfax, who was a close friend of George Washington. While inspecting canal operations at the Great Falls, Washington occasionally stopped at Towlston Grange. Jack and Ethel Durham purchased and restored the house in the 1930s. (Fairfax County Public Library Photographic Archive.)

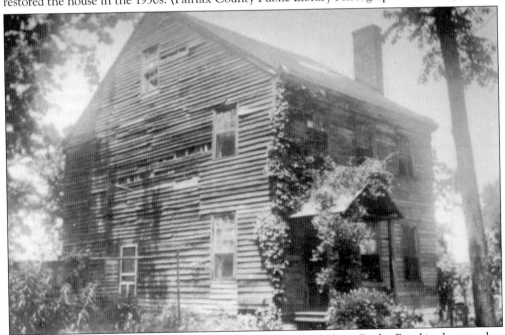

Strawberry Vale, c. 1782, was located about 200 yards north of Chain Bridge Road in the area that became the northwest loop of the interchange of Virginia Route 123 and Interstate 495. The house was torn down in 1958 for the development of Westpark Industrial Park and the construction of Interstate 495. It was briefly the residence of Richard Bland Lee after the American Revolution. (Fairfax County Public Library Photographic Archive.)

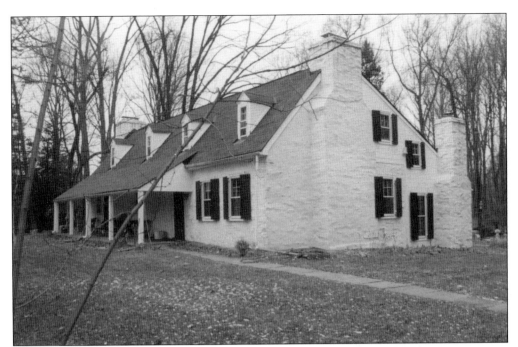

The Jackson House on Swink's Mill Road was built c. 1750 on the site of a former log cabin. Parts of the original walls were made of horsehair, plaster, mud, and stone and remain today. In 1843, the house, family cemetery, and surrounding property were sold but repurchased in 1940 by a Jackson descendent. (McLean & Great Falls Celebrate Virginia.)

The first Civil War civilian casualty was James Jackson, who once lived in the Jackson House. Jackson shot and killed New York Zouvaves' Col. Elmer Ellsworth after he removed the Confederate flag flying above Alexandria's Marshall Hotel. Union Corporal Francis Brownell immediately killed Jackson. Ellsworth was the first officer to be killed in the war. Jackson was buried in the family cemetery before being reinterred in Fairfax Cemetery. (Harper's Weekly.)

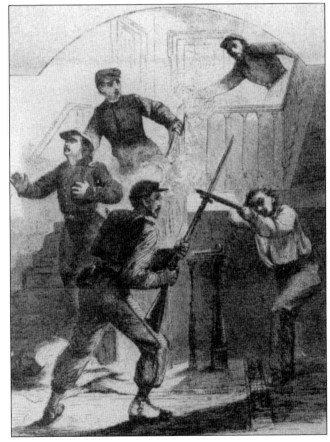

Benvenue was built around 1757 on part of the 3,402-acre Turberville grant known as Woodberry Hill. During the first winter of the Civil War, the house served as a hospital for Gen. Winfield Hancock's Fifth Wisconsin. Attic beams still have marks with names of many wounded or sick soldiers who were billeted there. A cottage in the rear was used as quarters for male nurses. (McLean & Great Falls Celebrate Virginia.)

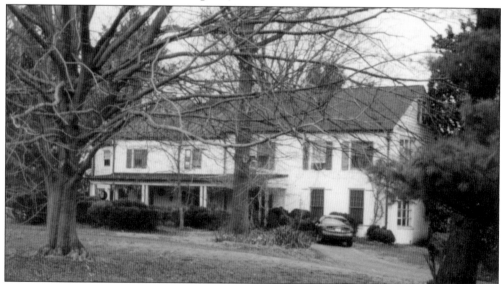

Minor's Hill was a simple log cabin before the Revolutionary War and has been added onto over time. President James Madison briefly stopped there the night the British burned Washington, and Dolley Madison spent two nights at Minor's Hill before returning to the city. During the Civil War, Federal troops established a signal tower, occupied the house, and camped on the surrounding grounds. (McLean & Great Falls Celebrate Virginia.)

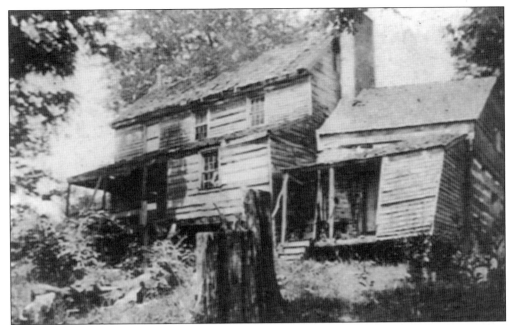

William Payne purchased 212 acres of land during the late 18th century on the eastern side of Kirby Road along Little Pimmit Run. A house was built around 1790, and it was abandoned around 1910, as shown above. Later Edward Carlin had the dilapidated house torn down; he moved a house from Georgetown across the Potomac and set it on the original foundation. (Fairfax County Public Library Photographic Archive.)

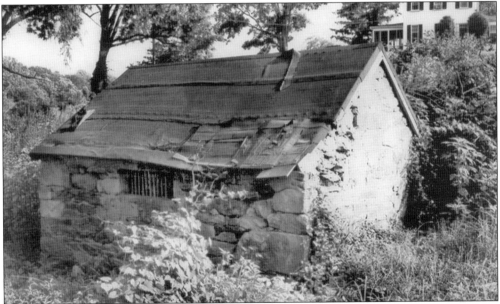

Even though the Payne house was destroyed, the original stone spring house remained at Pimmit Run, beside Chesterbrook Road. It, too, was neglected and eventually fell into disrepair; however, part of the stone walls and foundation remain today. In the background of the photo is the house that Edward Carlin had placed on the foundation of the former Payne house. (Fairfax County Public Library Photographic Archive.)

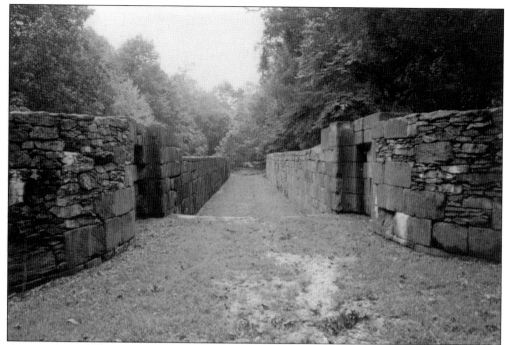

George Washington envisioned opening the west for commerce by linking the Potomac with the Ohio Valley. His plan required building locks and canals to circumvent the various falls of the river. The main obstacle was at the Great Falls where the river drops 80 feet in less than a half mile. Lock Number 1 was the largest of the five locks at Great Falls. (McLean & Great Falls Celebrate Virginia.)

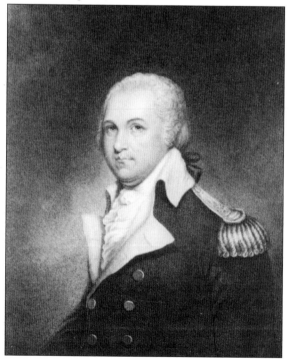

Henry "Light-Horse Harry" Lee supported George Washington's Patowmack Canal project. Lee developed a plan to capture the river trade at the Great Falls that was just as ambitious as that of Washington. A 40-acre town named Matildaville was incorporated December 16, 1790. It was laid out in half-acre lots and included, among many buildings, superintendent and laborer quarters, mills, warehouses, and a tavern. (Library of Congress.)

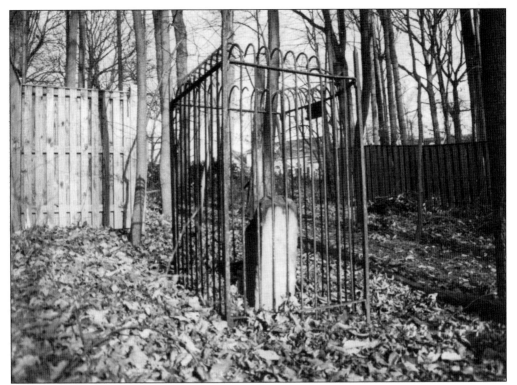

In 1791, a federal territory of 10 squared miles was established for America's seat of government. A boundary line of 40 sandstone markers was fixed at 1-mile intervals. However, that portion of Virginia within the District of Columbia was transferred back to the commonwealth in 1847 by the terms of the Retrocession Act of 1846. Stone NW1, shown above, is located on private property in Falls Church. (McLean & Great Falls Celebrate Virginia.)

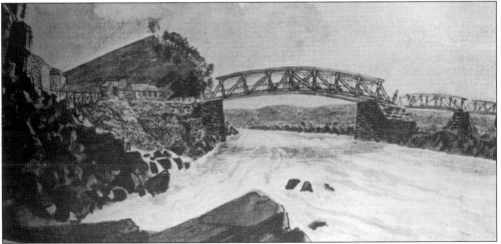

The first bridge across the Potomac opened for traffic in 1797 below Little Falls inside the District boundary line at Thomas Lee's former landing site. It stood seven years before being swept away by a freshet in 1804. The bridge has been replaced many times. The above watercolor of the bridge, known then as the Little Falls Bridge, was done by architect Benjamin Latrobe in 1800. (Library of Congress.)

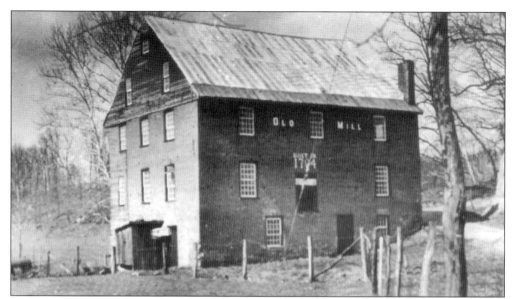

Grist mills were built along Potomac tributaries. The above mill was built *c.* 1794 just west of Difficult Run on what became the Alexandria-Leesburg Turnpike. It has been called Carper's Mill, Republican Mill, Powell's Mill, Millard's Mill, and the Brick Mill. The Fairfax County Park Authority acquired property in 1965 that included the mill and restored it as Colvin Run Mill. It opened it to the public in 1972. (Virginia Rita.)

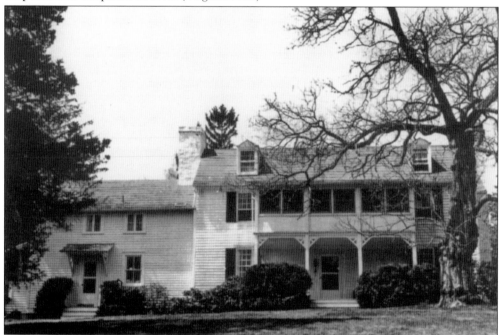

In 1808, William Swink purchased land and built a house named Spring Hill. The Swink family owned slaves and operated the property as a plantation until after the Civil War. Subsequent owners, such as Henry Alvord, Donald and Clara Beyer, and Peter Andrews made additions. The house and remaining 23 acres were sold in 2003 for the development of luxury single-family houses. (Fairfax County Public Library Photographic Archive,)

Two

EARLY DEVELOPMENT

By the start of the War of 1812 a few houses had been built in what later became McLean, but, with the exception of Salona, they were not notable. There had been considerations for a town adjacent to Thomas Lee's tobacco site. His eldest son, Philip Ludwell Lee, incorporated 100 acres in 1772 for a town named Philee, and John Turberville incorporated 20 acres nearby in 1798 for a town called Turberville. Neither town ever came to fruition and became known as "paper towns." Thomas Lee's property at Pimmit Run and the "paper towns" became part of Arlington County, but most of his 1719 grant remained in Fairfax County and is part of McLean.

Thus, the area was basically wilderness when the British burned America's capital city, and national leaders fled into the surrounding countryside. Pres. James Madison, first lady Dolley Madison, Secretary of State James Monroe, Attorney General Richard Rush, and Navy Secretary William Jones were among many who found safety in Northern Virginia. Dolley's escape took her across Chain Bridge and up Chain Bridge Hill before she stopped at Rokeby, the farmhouse of friends Richard and Matilda Lee Love. President Madison's route took him across Masons Island, through Falls Church, and to Minor's Hill where he briefly stopped; it is thought that he continued on to Salona, where he spent the night. Salona, once in possession of the Lee family, was then owned by the Rev. William and Anne Maffitt.

Eventually two small villages began to develop along the roads to and from Chain Bridge. One was at Langley Fork, where the Falls Rolling Road (Chain Bridge Road) and the Sugarlands Rolling Road (Georgetown Turnpike) joined. Benjamin Mackall purchased 540 acres from Elizabeth Lee in 1839 and retained the name Langley. An existing house was renovated and the family moved into it. A hamlet developed around the house. The second village formed at what is today Chain Bridge Road and Great Falls Street where, in 1846, the Lewinsville Presbyterian Church was built next to an existing cemetery in an already incorporated village named Lewinsville.

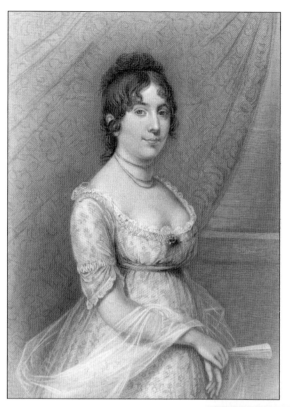

After American forces fell at the Battle of Bladensburg on August 24, 1814, President Madison and first lady Dolley Madison were forced to flee Washington City. After taking separate routes, they both found safety in the countryside of Virginia. Later that evening British troops entered the city and set fire to the public buildings that comprised America's seat of government. The first lady spent that horrific night at Rokeby, the home of a friend, Matilda Lee Love. It is thought that the president found shelter at Salona, the home of the Rev. William and Anne Maffitt. Both places were located in that part of Fairfax County which later became known as McLean. (Library of Congress.)

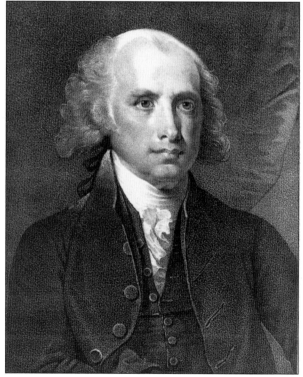

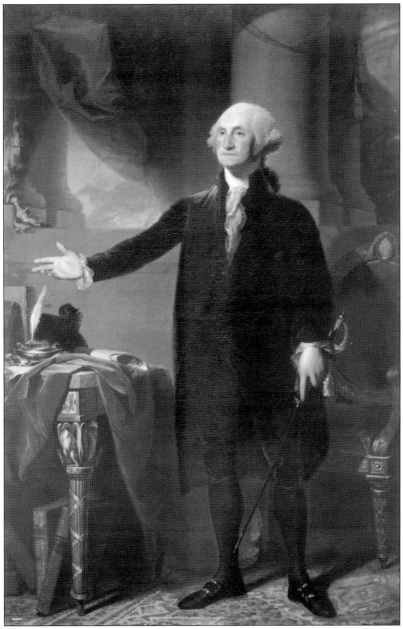

Before fleeing the President's House (White House), Dolley Madison made certain that the above full-length portrait of George Washington was secured; she did not take it with her. The painting was still hanging on the dining room wall when Dolley ordered that its outside frame be broken; the painting was never cut from its stretcher. Two friends, Jacob Barker and Robert DePeyster, later took it by wagon and hid it at a Maryland farm. This is perhaps America's most well-known presidential portrait. It is the third in a series of four of the exact same portrait and credited to Gilbert Stuart. The first in the series is known as the Lansdowne Portrait and is owned by the Smithsonian Institution. Stuart started the third portrait specifically for the President's House by painting the head and shoulders of Washington; however, William Winstanley, a landscape artist, completed the rest of the work. (Library of Congress.)

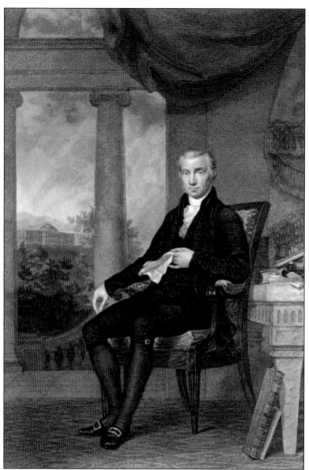

Secretary of State James Monroe also escaped into Virginia and stopped by Rokeby looking for the president. Not finding him there, Monroe continued on to Wiley's Tavern near Difficult Run where it is thought he spent the night. After returning to the city Saturday, August 27, 1814, Madison appointed Monroe acting secretary of war. Monroe's energetic spirit and decisive attitude helped restore confidence in the shattered administration. (Library of Congress.)

In 1808, a third bridge was built over the Potomac at Little Falls and named Chain Bridge. It was swept away in 1810 by flood waters and replaced with a similar structure which Dolley Madison used when escaping into Virginia. Included in the picture is an abandoned mill site where Stephen Pleasonton hid the Declaration of Independence and other valuables before taking them by wagon to Leesburg. (Library of Congress.)

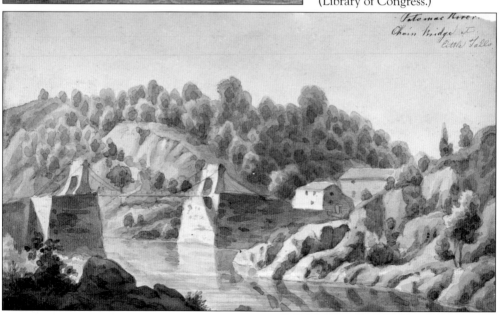

Salona was built facing the Falls Road (Chain Bridge Road). It is a Federal-style house where President James Madison may have stayed the night the British burned America's capital. The house served as headquarters for Union general William Smith during the winter of 1861–1862. The above photograph was taken after Clive and Susan DuVal restored the house in the mid-1950s. (Fairfax County Public Library Photographic Archive.)

The Rokeby estate has been in the hands of the Gantt family since 1817. The original farmhouse, where Dolley Madison spent the night, burned shortly after she was there. A second farmhouse was built around 1820. It also burned. A third white frame and clapboard farmhouse was built facing the Falls Road (Chain Bridge Road) around 1848. Merion Merrell is shown around 1940 with the third Rokeby farmhouse behind her. (Cornelia Stewart Gill.)

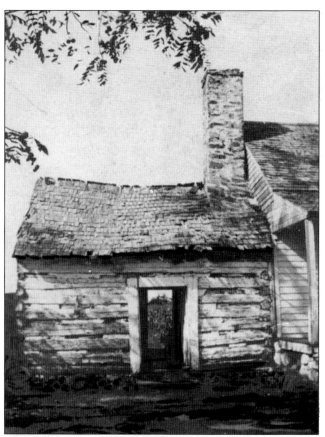

Paul Jennings, James Madison's servant and valued friend, probably spent the night the British invaded the City of Washington at El Nido, the log cabin home of the Rev. William and Sarah Adams Watters. Shown at left is a log attachment to a framed structure that was built over the original 1783 El Nido log house. (Gary Heath.)

The Rev. William Watters, the first American-born itinerant Methodist minister, married Sarah Adams, the daughter of Col. William and Ann Lawyer Adams of Fairfax County. Both are thought to be buried in the Adams, Wren, Watters Cemetery, a gravesite located on Linway Terrace that honors Rev. Watters. The photo shows the monument to Rev. Watters in the small cemetery. (McLean & Great Falls Celebrate Virginia.)

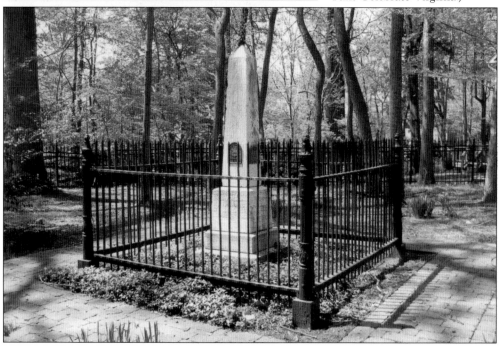

Thomas ap Catesby Jones lived at Sharon on the Georgetown-Leesburg Turnpike. During the War of 1812 his five-gunboat flotilla engaged a larger British force at Lake Borgne in 1815. The Americans were unsuccessful in stopping the enemy fleet from crossing the lake, but the British advance upon New Orleans was slowed, giving Gen. Andrew Jackson further time to prepare defenses for the city. (Fairfax County Public Library Photographic Archive.)

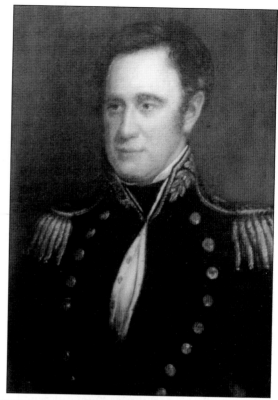

Sharon, built around 1810, was the home of Thomas ap Catesby Jones, which he inherited from his mother, Lettice Corbin Turberville. The house was located to the west of Langley on the Georgetown-Leesburg Turnpike. Bright Carper received the property in 1930 and operated a successful dairy farm consisting of at least 75 cows. The house was destroyed in 1963 for the development of Broyhill Estates. (Fairfax County Public Library Photographic Archive.)

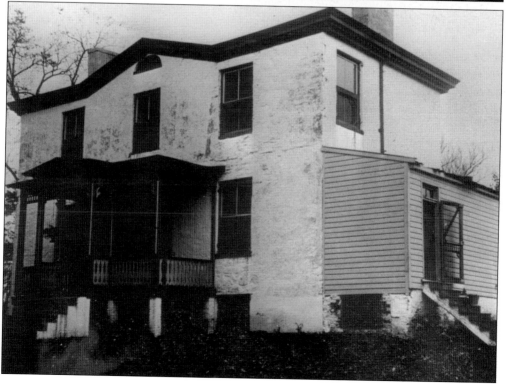

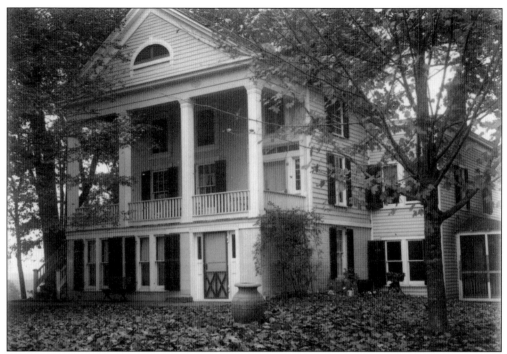

In 1839, Benjamin Mackall purchased 540 acres from Elizabeth Lee that were part of Thomas Lee's original Langley tract. He reconstructed an existing house on the Georgetown-Leesburg Turnpike, west of the fork, and resided there with his family. The hamlet of Langley grew around the house. In 1861, Benjamin was arrested by Union soldiers and imprisoned in Washington. The house burned down in 1936. (Fairfax County Public Library Photographic Archive.)

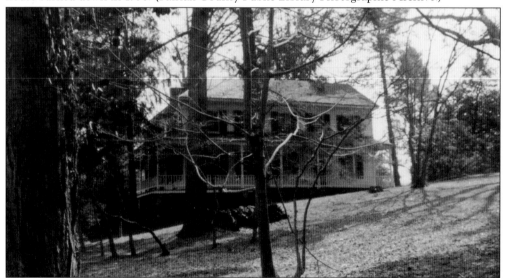

George Walters built the Langley Ordinary overlooking Langley Fork around 1850. The tavern part of the house was operated by his father-in-law, William Means. During the Civil War the house served as headquarters for Gen. George McCall of the Pennsylvania Reserves and was also used as a hospital. Dated signatures of Union soldiers remain on the inside walls of the house. (McLean & Great Falls Celebrate Virginia.)

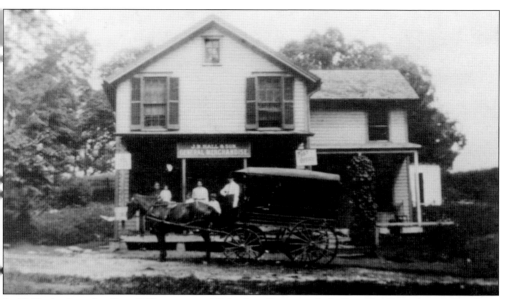

In 1846, the Langley Post Office was established at the crest of a hill on the Georgetown-Leesburg Turnpike at Langley Fork, and William Means was named postmaster. The post office was located in the above building, which also served as a hotel after the Civil War. The c. 1902 photo shows a combination general store and post office operated by the John Hall family. (Fairfax County Public Library Photographic Archive.)

The Falls Bridge Turnpike Company erected a tollhouse in 1820 on the Georgetown-Leesburg Turnpike. In 1889, Braden Hummer took down the original tollhouse and built a combination general store and dwelling house on the same site. He then sold groceries and, later, collected tolls. Today the second structure known as the Langley Toll House is part of the Langley Fork Historic District. (McLean & Great Falls Celebrate Virginia.)

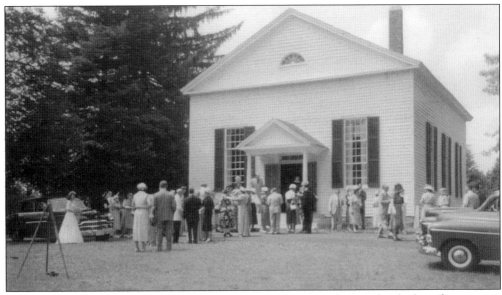

In 1846, the Lewinsville Presbyterian Church organized, and a simple clapboard sanctuary was built on land donated by the Ball family. Both the church and the incorporated village of Lewinsville were named after Troilus Lewin Turberville, the deceased brother of Martha Corbin Turberville Ball and Lettice Turberville Jones. The adjacent Lewinsville Cemetery predates the sanctuary. The photograph shows the 1951 wedding of Mary Stuelcken and Oliver Carter. (Mary Stuelcken Carter.)

The Lewinsville Post Office was established September 30, 1857, at Great Falls Street and Chain Bridge Road. The name changed to Kidwell's Crossroads in 1858, and later that year it became Anna. After the Civil War it reverted back to Lewinsville, until closing in 1911. The building was moved to the east on Great Falls Street in 1980 and is a private residence today. (McLean & Great Falls Celebrate Virginia.)

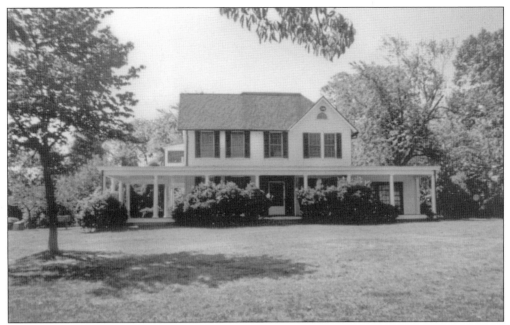

Meadowbrook was originally called Greenwood. The farmhouse was built around 1847 by John Gilbert in the hamlet of Lewinsville. The property was damaged during the Battle of Lewinsville and subsequent area occupation by Union troops. Charles and Ethel Hamel purchased Meadowbrook in 1941 and added onto the house. In 1973, the Fairfax County Park Authority purchased the property, retained the house, and created Lewinsville Park. (McLean & Great Falls Celebrate Virginia.)

It is thought that Jesse McVeigh built a four-room-hewn-log cabin around 1800 overlooking Lewinsville Road, known as Windy Hill. The house was purchased in 1869 by Jonathan Magarity, in whose family it remained until 1941. Over the years extensive additions have been made to the original log cabin, with clapboard placed over the original logs. More recent owners changed the name to Bois de Gosses. (Fairfax County Public Library Photographic Archive.)

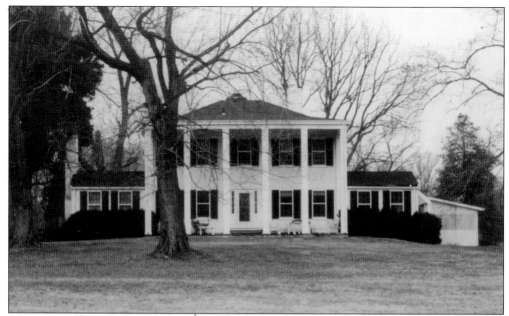

In 1854, Joshua Gibson purchased the portion of the Towlston tract that included a farmhouse called Valley Farm. There were subsequent owners and divisions of land by the time the Freeborn Jewetts purchased the property in 1960. They bought additional land, bringing their acreage to 25, and modernized the farmhouse. Valley Farm was later designated an Agricultural and Forestal District. (McLean & Great Falls Celebrate Virginia.)

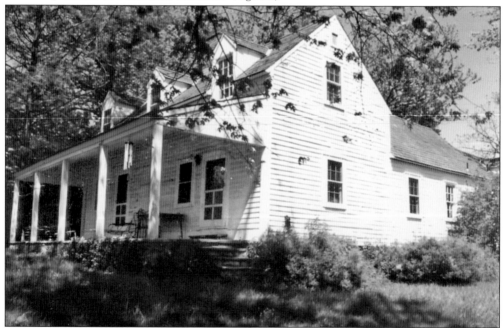

A small cabin built on Bellview Road with hand-hewn white oak logs was gutted and enlarged in 1940. All of the materials were saved, marked, and put back into the new house, now called Hifiter Road. The original logs were so solid that saws were broken when cutting them. At that time it was estimated that the cabin was over 200 years old. (McLean & Great Falls Celebrate Virginia.)

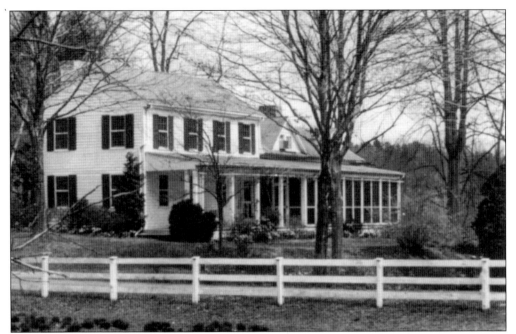

Thomas Peacock purchased 100 acres of land near Difficult Run in 1842 and built a log cabin upon which a second story log addition was later constructed. A farmhouse was later built that connected with the original log structure. The house became known as Peacock Station because a stop along the Great Falls & Old Dominion Railroad was near the house. (Fairfax County Public Library Photographic Archive.)

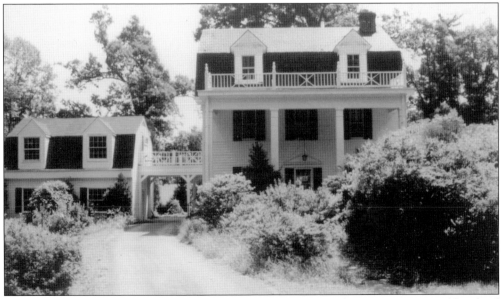

Abraham Mutersbaugh built a house around 1858 in a grove of oak trees on 60 acres of farmland along Kirby Road. Dr. Hugh Bennett, former chief of the Soil Conservation Service, later purchased the property, planted colorful gardens, and named it Eight Oaks. In 2005, the Symmes family preserved the remaining six acres through a voluntary land easement. (McLean & Great Falls Celebrate Virginia.)

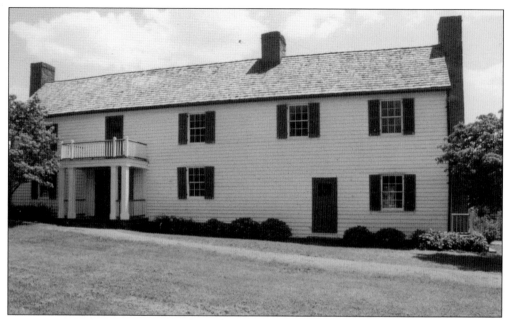

The Jackson-Jenkins Tavern, later known as the Dranesville Tavern, began operations on the Alexandria-Leesburg Turnpike around 1823. Until 1946, the tavern accommodated all who traveled the road. In 1968, the tavern was moved further back from Leesburg Pike and renovated by the Fairfax County Park Authority. It was placed on the National Register in 1972. (Fairfax County Public Library Photographic Archive.

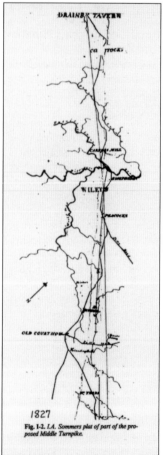

Fig. 1-2. I.A. Sommers plat of part of the proposed Middle Turnpike.

The Alexandria-Leesburg Turnpike was chartered by an act of Congress in 1813. Virginia's General Assembly proposed a more direct route in 1818 called the Middle Turnpike. The portion of the 1827 plat, drawn by I. A. Sommers, shows the proposed Middle Turnpike out to Dranesville Tavern through what later developed into Tysons Corner. The Middle Turnpike is today's Leesburg Pike (Virginia Route 7). (Fairfax County Office of Planning and Zoning.)

Three

CIVIL WAR

Shortly after the Southern victory at First Manassas on July 21, 1861, the task of better fortifying Washington City began. The building of Fort Marcy, part of a 37-mile circle of 68 forts and batteries, was undertaken by troops of Camp Advance to protect Chain Bridge. The villages of Langley and Lewinsville were located outside the circle, but near Fort Marcy.

A skirmish took place at Lewinsville on September, 11, 1861. Col. Isaac Stevens, 79th New York Infantry, with an aggregate force of 1,800, accompanied a survey crew headed by Lt. Orlando Poe of the Topographical Engineers to examine Lewinsville as a site for occupation. They remained several hours while rebels observed at a distance. When the survey was finished, recall was sounded. As Union troops formed into a column for their march back to camp, Confederate forces, led by Col. J. E. B. Stuart, commanding officer, First Virginia Cavalry, opened fire with guns and cannon. After experiencing heavy shelling, the Yankees eventually silenced the rebel guns. Reports vary as to the casualties. At least three Yankees were killed, several were wounded, and four were taken prisoner; Stuart claimed there was no injury to any of his men. There were further skirmishes around Lewinsville, but this was the primary event and became known as the "Battle of Lewinsville."

The Army of the Potomac remained in Northern Virginia throughout the fall and winter of 1861–1862. Camp Griffin, the encampment of the Vermont Brigade, occupied Salona property beginning in October 1861; the Salona house served as headquarters for division commander, Gen. William ("Baldy") Smith. Sickness and disease overran the camp. Many died without seeing battle. Property around Benvenue, a stone house across from Salona on Chain Bridge Road, was converted into a hospital tent city, while the house itself served as a hospital and headquarters for Gen. Winfield Hancock's Fifth Wisconsin. The Langley Ordinary became a hospital and headquarters for Maj. Gen. George McCall, commander of the Pennsylvania Reserves. The troops ravaged and plundered the countryside. With the arrival of spring, McClellan's army departed for the Peninsular Campaign, unconcerned with the destruction it left behind.

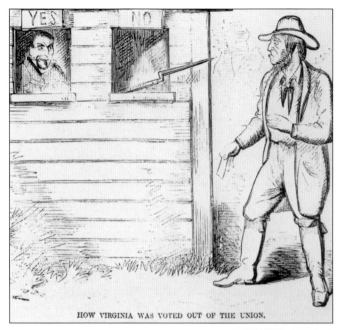

HOW VIRGINIA WAS VOTED OUT OF THE UNION.

At a convention held in Richmond, delegates passed an Ordinance of Secession on April 17, 1861; however, the decision was subject to public approval by a referendum held May 23, 1861. It was clear that Virginia would secede, but voter intimidation by a few secessionists took place to make certain that Virginians voted its passage. The *Harper's Weekly* cartoon at left suggests that voters encountered difficulties at the polls. (*Harper's Weekly.*)

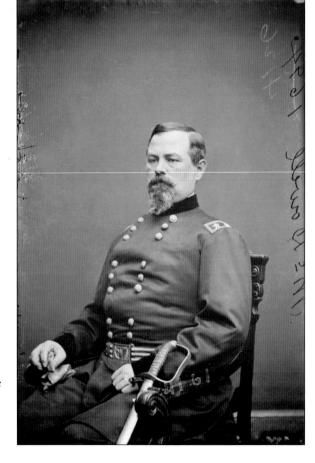

Pres. Abraham Lincoln appointed Gen. Irvin McDowell (right) commander of the principal Union army to protect Washington City. McDowell ordered 35,000 troops into Virginia on July 16, 1861. Several brigades crossed Chain Bridge and marched through Langley and Lewinsville on their way to the battle site. The premature offensive against Confederate forces resulted in the First Battle of Manassas, a disaster for the Union. (Library of Congress.)

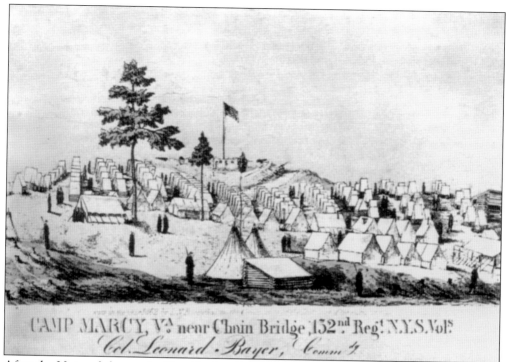

After the Union defeat at the First Battle of Manassas the federal government began building a system of fortifications around Washington City. Fort Marcy was constructed on high ground overlooking the Georgetown-Leesburg Turnpike (Chain Bridge Road) to protect the Chain Bridge. The above sketch was drawn by a Federal soldier and shows the garrison's tents set up around the earthwork fort. (Fairfax County Public Library Photographic Archive.)

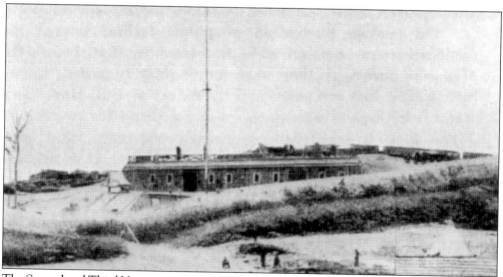

The Second and Third Vermont regiments began constructing Fort Marcy in September, 1861, but it was not entirely completed until the fall of 1862. The picture shows Fort Marcy as it appeared during the Civil War. All that remains of the site today are the entrenchments, which have been very well preserved. (Hyland C. Kirk.)

Fort Marcy was originally called Fort Smith after Gen. William ("Baldy") Smith, whose division began construction of the fort in 1861, but Gen. Randolph Marcy, chief of staff to Gen. George McClellan and also his father-in-law, received the final honor. This *c.* 1925 photo shows what remained of Fort Marcy long before it was turned into a public park administered today by the National Park Service. (Mary Anne Hampton.)

Salona was a 208-acre working farm when Union troops occupied the property and established Camp Griffin. The house served as the headquarters for division commander Gen. William ("Baldy") Smith. Salona's owner, Jacob Gilliam Smoot, spent most of the war living in Georgetown. Smoot was denied his reparations claim because he had signed the May 23, 1861 Ordinance of Secession at the Lewinsville precinct. (Fairfax County Public Library Photographic Archive.)

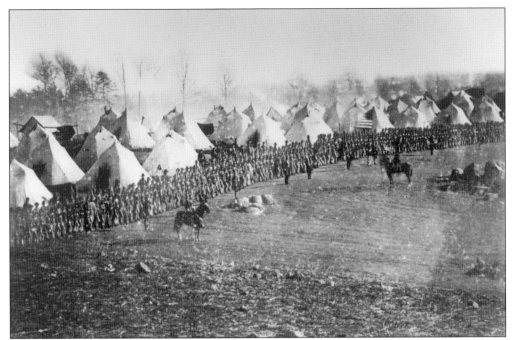

George Houghton took the above photo, showing Col. L. A. Grant on horseback reviewing troops of the Fifth Vermont Infantry at Camp Griffin in late fall of 1861. The rock formations shown to the far right of Col. Grant, who is on horseback facing the troops, remain today in McLean on Kurtz Road in front of a private residence. (Fairfax County Public Library Photographic Archive.)

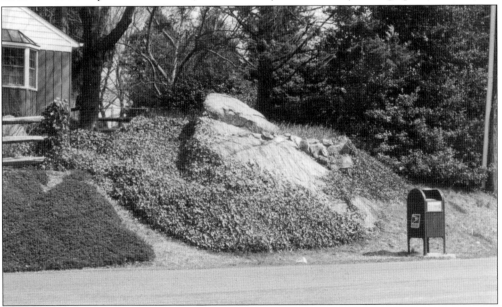

This is a modern-day photograph of the rock outcroppings in the top photograph that shows the Fifth Vermont Infantry lined up for review. Surprisingly, the rock formations withstood development and the bulldozer when building Salona Village, a neighborhood of single family homes that was constructed in stages beginning in 1950 on a portion of the original Salona property. (McLean & Great Falls Celebrate Virginia.)

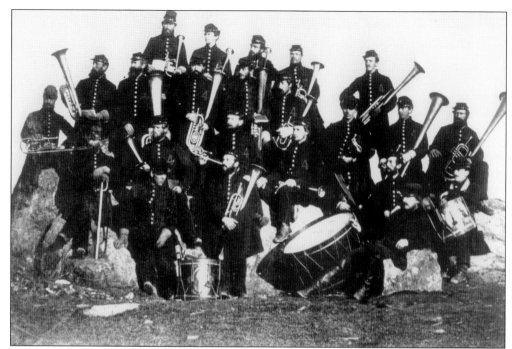

George Harper Houghton was a photographer and artist from Vermont who followed the Vermont Brigade. He took numerous Civil War photographs and produced many drawings of his fellow Vermonters. While stationed at Camp Griffin the Fourth Vermont Infantry band gathered for this photograph on the rock formations that remain today on Kurtz Road. (Fairfax County Public Library Photographic Archive.)

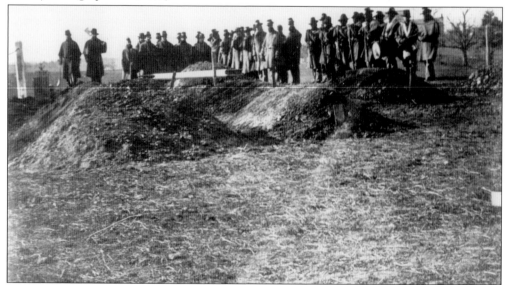

Sickness and disease ran rampant throughout Camp Griffin while encamped at Salona. The diet was insufficient and the sanitary conditions were terrible. Many suffered from diarrhea and dysentery, but when measles broke out the death list began to grow. Many soldiers died an inglorious death without having faced the enemy in battle. Burial services, such as the above at Salona, were common. (Fairfax County Public Library Photographic Archive.)

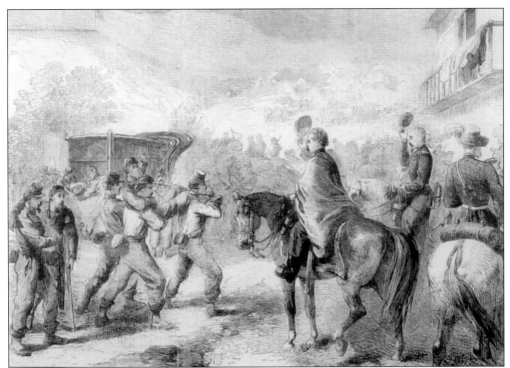

On September 11, 1861, an aggregate force of 1,800 Federal troops reconnoitered the Lewinsville area for possible occupation. While they formed a withdrawal column, waiting Confederates under the command of Col. J. E. B. Stuart attacked. Generals George McClellan and William Smith are astride horses in the above picture, "Bringing in the Federal Wounded after the Skirmish at Lewinsville, Virginia." (*Harper's Weekly.*)

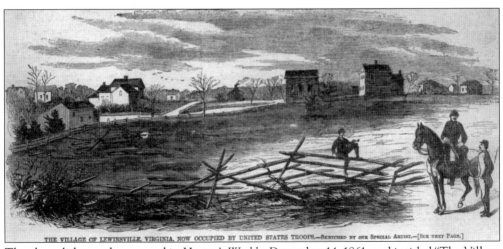

THE VILLAGE OF LEWINSVILLE, VIRGINIA, NOW OCCUPIED BY UNITED STATES TROOPS.—Sketched by our Special Artist.—[See next page.]

The above lithograph appeared in *Harper's Weekly*, December 14, 1861, and is titled "The Village of Lewinsville, Virginia, now occupied by United States troops." This appears to be a whimsical sketch of Lewinsville. Except for the crossroads, the picture has little to do with the village of Lewinsville at that time: there is no church, graveyard, post office, or the John Gilbert House that is called Meadowbrook today. (*Harper's Weekly.*)

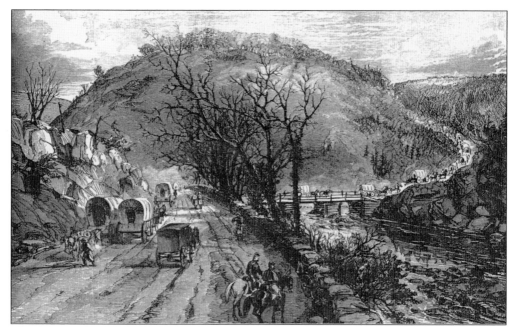

This lithograph appeared *in Frank Leslie's Illustrated Newspaper*, January 18, 1862. Union wagons and troops are headed toward Chain Bridge on the Georgetown-Leesburg Turnpike (Chain Bridge Road). Pimmit Run is to the right. Before reaching the Potomac River, the column crosses the Pimmit Bridge and moves up the new Military Road (Glebe Road) built by troops of Gen. William Smith's division. The stone wall remains today. (*Frank Leslie's Illustrated Newspaper.*)

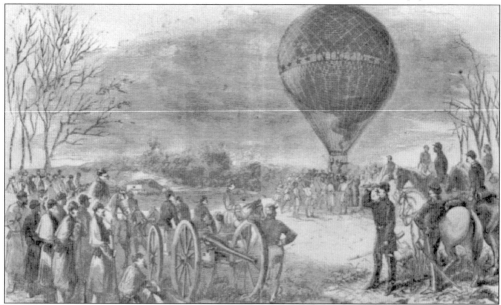

The Union Army Balloon Corps, directed by a civilian, Professor Thaddeus Lowe, was established early in the Civil War to reconnoiter enemy activities from the air. This lithograph from *Harper's Weekly*, December 14, 1861, depicts Professor Lowe making a reconnaissance mission for Gen. William Smith's division of the Army of the Potomac in the vicinity of Vienna, Virginia. (*Harper's Weekly.*)

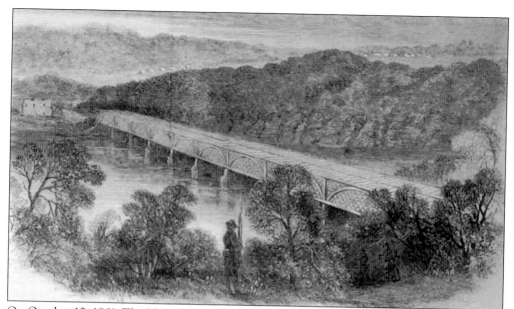

On October 12, 1861, Thaddeus Lowe and a small crew hauled a fully inflated gas-filled balloon overnight from Washington City across Chain Bridge to Lewinsville. Arriving at their destination at daybreak, the exhausted men tethered the balloon to tree stumps, only to watch it float away shortly thereafter during a violent storm. This view of Chain Bridge is from the District side looking towards Virginia. (Library of Congress.)

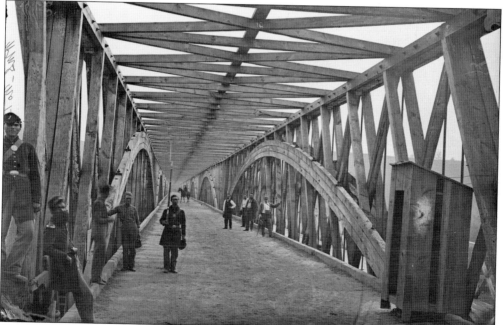

Thaddeus Lowe and his crew were unable to drag a fully inflated gas-filled balloon across the roadbed of Chain Bridge. In order to get the balloon over the Potomac, the balloon was raised and the men, with the balloon above their heads, crawled across the top of the pictured bridge during darkness and maneuvered it across the river; Lowe directed operations from the wicker basket above them. (Library of Congress.)

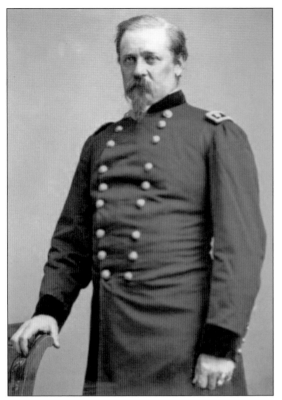

Gen. William ("Baldy") Smith was commander of the Second Division of McClellan's army. He was instrumental in forming the Old Vermont Brigade, composed of the Second, Third, Fourth, Fifth, and Sixth Vermont Infantry Regiments. This was the first brigade in the army formed with troops from a single state. Smith headquartered at Salona during the winter of 1861–1862, and the brigade formed Camp Griffin on the surrounding grounds. (Library of Congress.)

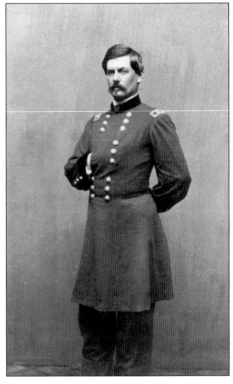

After the First Battle of Manassas, Gen. George McClellan was summoned to Washington where he organized the Army of the Potomac, the military force responsible for defending the Federal capital. When Gen. Winfield Scott retired, November 1, 1861, McClellan became general-in-chief of all the Union armies. He was occasionally in what later became the McLean area inspecting troops or as part of a reconnaissance mission. (Library of Congress.)

Four

REBUILDING

The damage to the countryside was challenging for residents to overcome as they picked up their broken lives and faced post–Civil War rebuilding. This was a period of adjustment and most struggled just to eke out a livelihood. Northerners had started migrating to Fairfax County before the war, but they moved to the county in large numbers when it ceased because the land was cheap. These Northerners were able to farm the war-torn property because they were used to cultivating the fields themselves. These farms became substantial properties, owned by "newcomers" with names like Magarity, Storm, Laughlin, Heath, Elgin, Mutersbaugh, Beall, Drew, and Carper.

Many African Americans took advantage of the opportunities now offered them and purchased land. Three such individuals were Christopher Columbus Hall, Cyrus Carter, and Alfred Odrick. Hall established a dairy farm in Lincolnsville (now Chesterbrook) and later opened a store in the District. Many of his descendents continue to reside on Cottonwood Street, which is part of the original Hall property. Carter donated land on Kirby Road in 1866 for the construction of a church—the First Baptist Church of Lincolnsville (now Chesterbrook). He also founded the Shiloh Baptist Church in 1873 with seven members, and on September 25, 1887, he laid the cornerstone for Shiloh, which was built on Spring Hill Road; the dedication service was held October 11, 1891.

In 1872, Alfred Odrick built his residence near the junction of Lewinsville and Spring Hill Roads. A Freedmen's community developed in that area. Odrick's Public School was constructed in 1879 adjacent to his property. It served the dual function of both school and church for members of Shiloh Baptist. Another African American, Samuel Sharper, who already owned land along Towlston Road, headed a congregation that formed the Pleasant Grove Methodist Episcopal Church in 1882, which also worshipped at Odrick's Corner School. Ultimately they were able to purchase land to the west of the school further down Lewinsville Road. The first service held in the Pleasant Grove Church was in 1896.

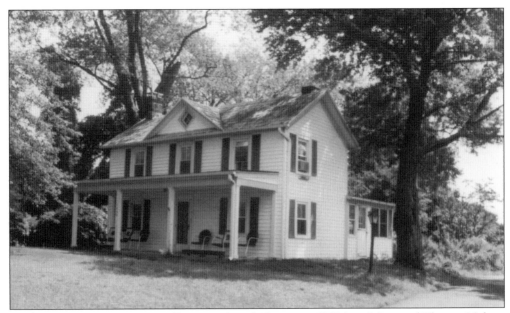

For $250, Sarah and George Faulkner purchased 10 acres in 1857 from Mary and Thomas Nelson and built the above house on Kirby Road. Their property was considered part of Falls Church at that time. After the Civil War concluded, the area along Kirby Road was named Lincolnsville, and sometime before 1900 it was renamed Chesterbrook. Today it is a part of McLean. (McLean & Great Falls Celebrate Virginia.)

This photo of Sally Ball Faulkner, the second wife of George Faulkner, was taken prior to 1898. Shortly after the Civil War ended, Confederate soldiers were walking through the fields searching for food. Sally, a loyal Unionist, took pity and gave them everything edible from the house. The two jars in the background have survived over the years, and remain today with her great-granddaughter. (Elaine Strawser Cherry.)

This c. 1916 photo shows Selma Faulkner (Strawser) standing in the driveway of her parents' home at Kirby and Chesterbrook Roads. Her parents, Wilfred and Katie Faulkner, are in the buggy; Henry Beall, who lived nearby, is sitting on the side porch. The house remains today in the hands of the original family. (Elaine Strawser Cherry.)

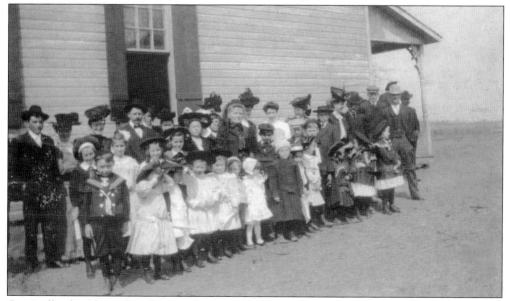

Originally, the Chesterbrook Methodist Episcopal Church used the Chesterbrook School to hold its services. The school at that time was on Linway Terrace at Kirby Road. This photo, with the school building in the background, was taken in 1906 when the church formed. Pictured are members of the Phillips, Hall, Reed, Stalcup, Beall, Faulkner, Devine, Leigh, Byrnes, Mutersbaugh, Ball, Schoon, Johnson, Hough, Brown and Jenkins families. (Peggy Stalcup Byers.)

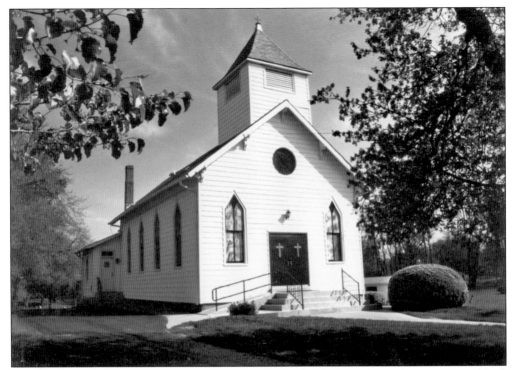

First Baptist Church Lincolnsville was founded in 1866 by the Rev. Cyrus Carter to serve black residents in the Lincolnsville community. It was built on Kirby Road on property donated by Carter, who had purchased the land from Gen. John Crocker. It was renamed First Baptist Church Chesterbrook when the area changed its name to Chesterbrook. The top photo is the second church that was built in 1911 on the original site. Black youth were educated at the Chesterbrook Colored School in the Oddfellows Lodge, which was on the church property. The Lodge building was taken down in the late 1950s. All that remains of the Chesterbrook Colored School is the flag pole shown in the lower photograph. (McLean & Great Falls Celebrate Virginia.)

Shiloh Baptist Church organized with seven members in 1872, under the leadership of the Rev. Cyrus Carter, who also founded First Baptist Church Lincolnsville in 1866. Initial services were conducted in the Odrick School House. As the congregation grew, its members wanted to worship in their own church. A quarter-acre of land was purchased from Charles Elgin on Spring Hill Road for erecting a church. The dedicatory services were held on October 11, 1891. Six adjacent acres were later acquired and a cemetery for church members was established behind the building. The original church burned in 1926; it was rebuilt three years later on the same site. The top photo is of Shiloh before it was destroyed by fire, and the lower photo shows the church building in 1973. (Archie Borgus III.)

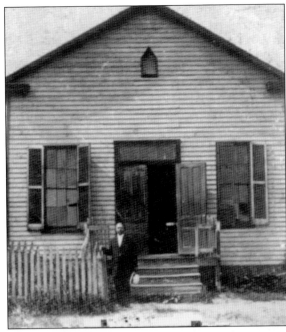

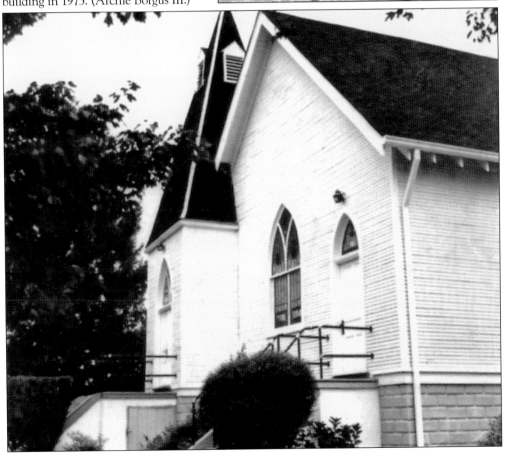

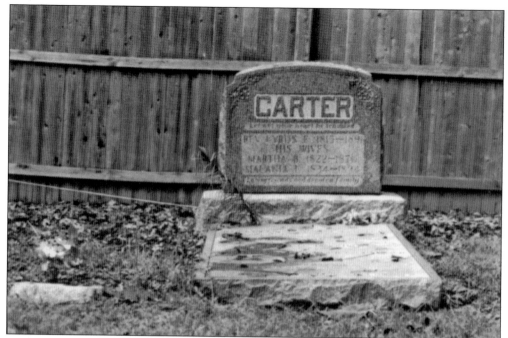

Rev. Cyrus Carter was born in Haiti and came to the United States as an infant. He is buried in the cemetery adjacent to First Baptist Church Chesterbrook (Lincolnsville) that he founded in 1866. Rev. Carter helped establish Shiloh Baptist Church in 1873, but died before the first cornerstone was laid on Spring Hill Road. (McLean & Great Falls Celebrate Virginia.)

This monument is located in back of Linway Terrace Park. It was built by artist Georgia Jessup to honor her ancestors, Maria and Christopher Columbus Hall, who purchased 26 acres in 1865 in Lincolnsville from Francis Crocker and his wife. Hall established a dairy farm and later opened a store in Washington. Many Hall descendents remain on the original property, living on Cottonwood Street. (McLean & Great Falls Celebrate Virginia.)

Gunnell's Chapel is a small one-room wooden structure that was constructed in 1877 along Georgetown Pike on land donated by the Robert Gunnell family. The church was built directly beside the Langley Toll House and served as a place of worship for black Methodists and as a schoolhouse for blacks in the surrounding area. (Fairfax County Public Library Photographic Archive.)

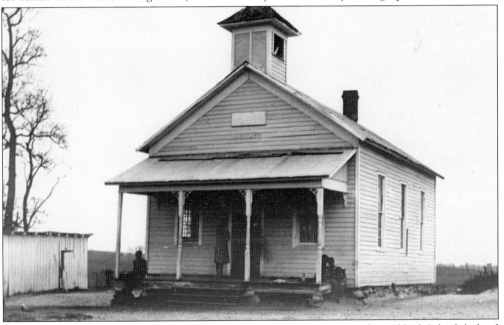

To educate the black population residing along the Lewinsville Corridor, Alfred Odrick helped organize the one-room Odrick Schoolhouse that was built adjacent to his property in 1879, at the southwest corner of Lewinsville and Spring Hill Roads. The wooden building was taken down around 1943 and replaced with a larger brick structure that closed in 1954. The Charity Baptist Church is on that site today. (Fairfax County Public Library Photographic Archive.)

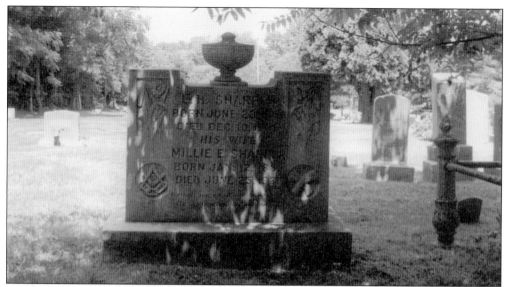

After the Civil War many blacks built their own churches. The Pleasant Grove Methodist Episcopal Church congregation formed with seven trustees: Samuel Sharper, John Willard, Elmead Sharper, William Sharper, William Hatcher, William Harris, and William Grayson. An acre of land was acquired November 8, 1893, for the church. Samuel Sharper died before construction was finished and was the first to be buried in the adjacent cemetery. (McLean & Great Falls Celebrate Virginia.)

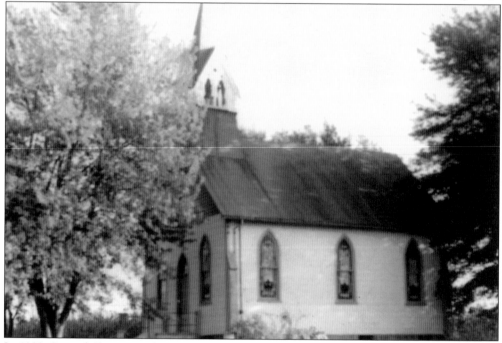

In 1882, Samuel Sharper and six trustees appealed to the Washington Conference, Lynchburg District, Langley Circuit, for a church on Lewinsville Road. Pleasant Grove Methodist Episcopal Church first held services at Odrick's Corner School in 1892. In 1896 members began worshipping in their new church and continued there until 1968 when the building was sold. Shown above is the church in 1958 with its stained glass windows. (Archie Borgus III.)

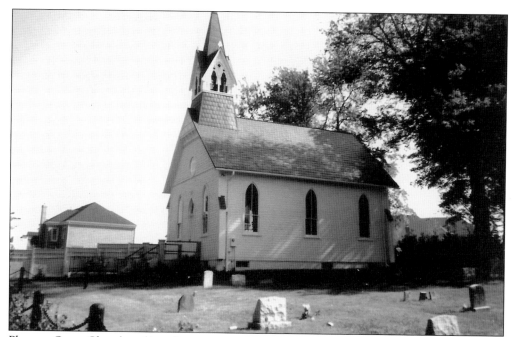

Pleasant Grove Church and its adjoining cemetery remain on Lewinsville Road. Friends of Pleasant Grove Church organized in 1982, and were instrumental in saving the building from demolition. Friends restored the church, only to have lightning strike the steeple in 1992. The old steeple was replaced the following year. The photo shows the church with its replaced steeple alongside a new housing development. (McLean & Great Falls Celebrate Virginia.)

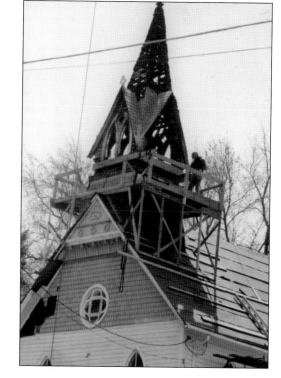

The interior of Pleasant Grove Church was damaged from water used to douse the fire when lightning struck the steeple in July 1992. The steeple was restored and the church's basement was turned into the first African American museum in Fairfax County. Most of the historical memorabilia on display belonged to Frances Moore, a descendent of one of the original members. (Jan Elvin.)

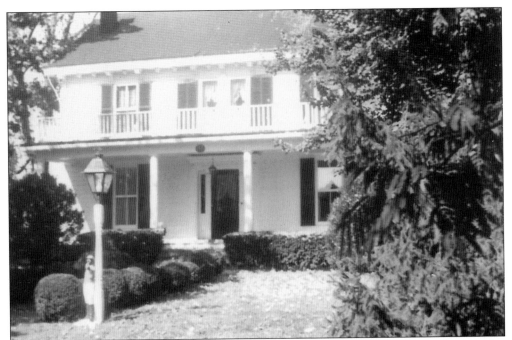

After the Civil War, Emma and John Shafer built a house on a knoll overlooking Chain Bridge Road. They farmed 89 acres and took in drovers. The house was surrounded by majestic chestnut trees and was named Chestnut Hill. Francis Walters purchased the farm in 1924 and sold it in sections. Mary and Stuart Robeson purchased the house and remaining four acres in 1948 and renamed it Merryhill. (Palmer Robeson.)

Hickory Hill was built around 1870 on the foundations of an earlier house constructed by George Walters around 1846 on Chain Bridge Road, which was burned during the Civil War. Over time there have been numerous changes to the house. Hickory Hill has been the residence of Associate Supreme Court Justice Robert Jackson, Sen. (later president) John and Jacqueline Kennedy, and Sen. Robert and Ethel Kennedy. (McLean & Great Falls Celebrate Virginia.)

This 1895 picture shows the George Drew farmhouse located on 51 acres of land facing Chain Bridge Road across from today's Lewinsville Park. Expanding to 108 acres, the property was named Kenilworth Farm and became a major dairy farm in Fairfax County. Until it was torn down for building Broyhill McLean Estates, the farmhouse featured two bullet holes from a Civil War engagement at Lewinsville. (David Gilpatrick.)

By 1870, Fairfax County was the largest milk producer in Virginia. Kenilworth Farm, shown above, was very serious about its dairy herd, which consisted of registered Guernsey cattle. Kenilworth's herd was judged "Best Dairy Herd" in the Cattle Department of the Fairfax County Fair for 1920, 1921, and 1922. (David Gilpatrick.)

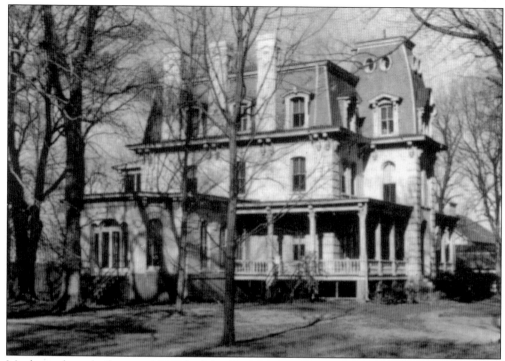

Maplewood was built around 1870 by John Shipman on Chain Bridge Road, and was originally called Villa Nova. The name Maplewood first appeared when Charles Brodt purchased the property in 1912. Dr. Sidney and Ethel Ulfelder bought Maplewood in 1925 and turned it into a prosperous dairy farm. Maplewood was sold to the West*Group in 1962; the house was later demolished in 1970. (Fairfax County Public Library Photographic Archive.)

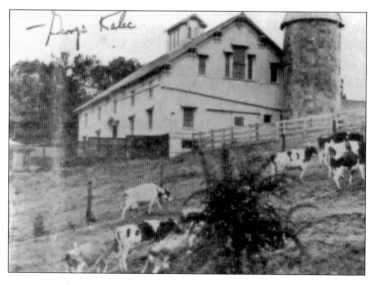

Maplewood was a dairy farm. A magnificent large barn, measuring about 200 feet in length and 75 feet in width, was located near the house. It was two-and-a-half stories high and put together with pegs. The bottom floor, where the milk stanchions were, was made of cement and the upper floors were made of wood. (Fairfax County Public Library Photographic Archive.)

The congregation of the Trinity Methodist Church built the clapboard church at right in Langley on Georgetown Pike in 1893. When they built a brick church on Dolley Madison Boulevard they sold the wooden structure to the Lutheran Church of the Redeemer in 1957. The Lutherans sold the building to the Religious Society of Friends (Quakers) in 1961, and it became known as Langley Friends Meeting House. (McLean & Great Falls Celebrate Virginia.)

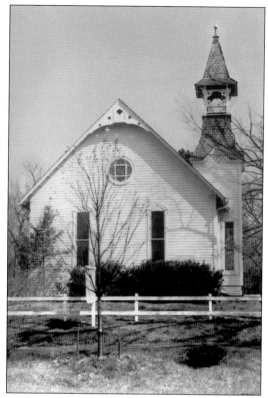

Harry Shannon, a writer for the *Washington Star* newspaper, took the above photograph of the Langley Toll House (left) in 1918 during one of his "Rambler" walks. At this time the house was owned by Braden Hummer, who collected tolls and operated a general store. Of interest in the photo is the nearness of the building to the Georgetown Turnpike. (Fairfax County Public Library Photographic Archive.)

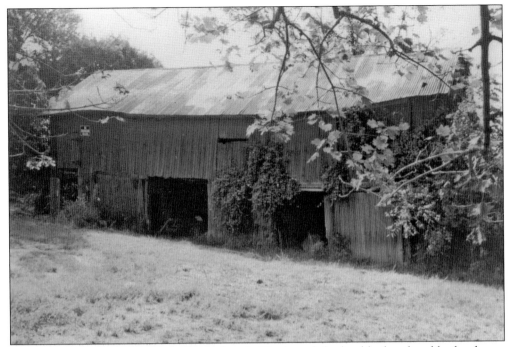

Guy Beall purchased 11 acres in Chesterbrook. He cleared the land by hand and built a house and the pictured barn on Kirby Road. He was a truck farmer and took his fruits and vegetables into the District. His son John raised Guernsey cows; for years, the family sold milk, cream, and butter to regular customers from their back porch. (Janet Beall.)

The home of Della and Guy Beall was built in 1898. Besides selling dairy products, the family sold fresh fruits and vegetables from a stand underneath a tree in the front yard. The house sat vacant from 1986 to 2001; it was demolished and replaced with four single family dwellings. While unoccupied it became known as "The Bat House" because bats used the empty house as their habitat. (Steve Sommovigo.)

Hattie and Joseph Trammell acquired 99 acres of the "Balls Hill Land" in 1890 and bred horses. In 1910, their son, French Trammell, was deeded 50 acres of the property. He built Woodbine and established a dairy farm. Descendents sold most of the property between 1957 and 1966 for the Langley Manor subdivision and Churchill Road Elementary School. Today Woodbine remains on just 17,719 square feet. (McLean & Great Falls Celebrate Virginia.)

The Ball family returned to their Prospect Hill property after the Civil War and found it completely destroyed. Family members later built Woodberry, which was part of the property the Trammells acquired in 1890. Flora Trammell married Catesby Swink. They lived at Woodberry farming 40 acres. The farmhouse remains; the Heather Hill subdivision, Sharon Masonic Temple, and Cooper Intermediate School occupy the former property. (McLean & Great Falls Celebrate Virginia.)

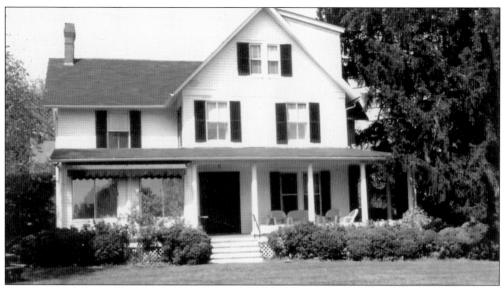

Because the Ball property at Georgetown Pike and Balls Hill Road was wasted by Union troops, family members constructed several small cabins from salvageable materials in which to live. In 1905, William Selwyn Ball built Elmwood further down Balls Hill Road after he received funds for granting a right-of-way for the Great Falls and Old Dominion Railroad to pass through his land. (McLean & Great Falls Celebrate Virginia.)

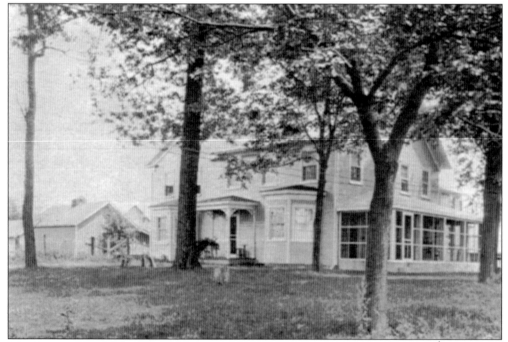

John Storm married Sarah Magarity, a daughter of Johnathan and Frances Magarity, in 1877. He purchased the Magarity farm and turned it into a large dairy operation. With John Sherwood he owned the Storm and Sherwood Dairy, a processing plant in Georgetown. A son, J. Clemons Storm, later operated the farm, bringing it to peak production during World War II. The Storm house, pictured around 1900, is shown above. (McLean Remembers Again.)

The Matthew Laughlin farmhouse was built around 1900 facing Chain Bridge Road. Laughlin owned and operated a very large dairy farm that stretched from Chain Bridge Road down to at least Pimmit Run. After Laughlin's death his son Clifton acquired the property. Clifton Laughlin started McLean's first real estate company in 1933. Today Total Beverage occupies the site of the former farmhouse. (Kip Laughlin.)

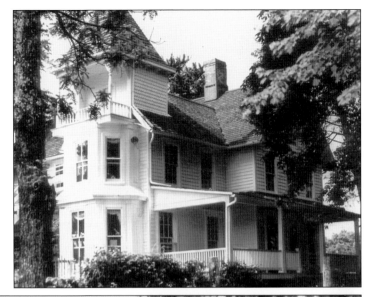

Edward Heath is relaxing at age 89 in the backyard of the farmhouse that he built in 1903 with his brother-in-law, Clyde Taylor, on Old Chesterbrook Road in the El Nido community. The Heath farm grew several varieties of vegetables and fruits and trucked them into the District markets. They also raised cattle, pigs, and chickens. All but two acres that included the house were sold in 1959. (Gary Heath.)

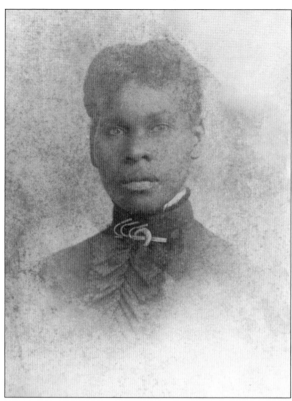

Lucy Turner was a former slave who grew up on a farm in what later became a part of McLean. She gained her freedom at the close of the Civil War. Lucy had 10 children. One of her daughters, Ada, married J. Henry Borgus, who built a farmhouse (Ash Grove Farm) to the west of Odrick's Corner facing Leesburg Pike where they raised their family. (Archie Borgus III.)

J. Henry Borgus bought 27 acres from R. A. Poole in 1892, and built Ash Grove Farm at the junction of Lewinsville Road and Leesburg Pike. Twenty-three acres of his purchase were on the opposite side of Leesburg Pike. In 1970, Archie Borgus Sr. sold that portion to the National Wildlife Federation. Five generations of the Borgus family have lived in the original house. (McLean & Great Falls Celebrate Virginia.)

Five

BIRTH OF A VILLAGE

McLean can trace its beginning to 1902 when John R. McLean and Sen. Stephen Elkins of West Virginia obtained a charter to operate a trolley line, called the Great Falls and Old Dominion Railroad. This was simply a business venture to promote the scenic beauty of the Great Falls of the Potomac. The 14-mile electrified railroad ran between Rosslyn and the falls, linking with Washington, D.C., via the old Aqueduct Bridge. Its rails were laid through forests, farmland, and fruit orchards, bypassing the existing villages of Lewinsville and Langley. The trolley began operating July 3, 1906, with a trial run to the Great Falls, but its first scheduled passenger trip was the following day, July 4, 1906.

One of the stops was at Chain Bridge Road, which was and still is a major transportation artery through Fairfax County. At first the stop was called Ingleside after a community that was beginning to develop along Elm and Poplar Streets. However, by 1910, the Ingleside name had changed to McLean, honoring one of the trolley's founders, who was also the publisher of the *Washington Post* newspaper; and so, the next stop down the line, to the west, became known as Ingleside. In June of that same year Henry Alonzo Storm took over the operations of a general store adjacent to the tracks at Chain Bridge Road and Elm Street that already contained the McLean Post Office. In 1911, the Chesterbrook, Lewinsville, and Langley post offices were abolished and folded into the existing McLean Post Office.

The Great Falls and Old Dominion Railroad had a tremendous impact upon the Northern Virginia area. Farmers found it less difficult to get their crops and dairy products to market. Businessmen discovered the art of commuting and sought permanent or summer homes for their families in the countryside. Little settlements, such as Franklin Park and El Nido, developed at several stops along the route, but the area surrounding the McLean stop underwent the most change: it became important for residents, organizations, and businesses to locate near that stop.

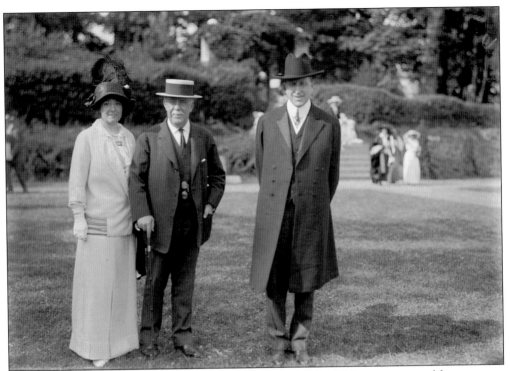

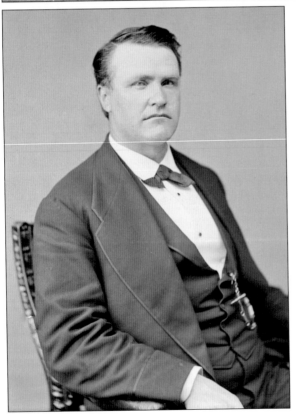

John McLean was a wealthy entrepreneur and powerful political figure from Ohio. With Sen. Stephen Elkins, he purchased the Great Falls and Old Dominion Railroad in 1902 and constructed an electrified railroad that linked Rosslyn with Great Falls Park. The stop at Chain Bridge Road was named after him. In 1905, McLean purchased the *Washington Post* newspaper. The photo shows Millicent Hearst, McLean, and William Randolph Hearst. (Library of Congress.)

The stop at Georgetown Pike was named Elkins Station after Sen. Stephen Elkins, who, like John McLean, was a wealthy businessman and powerful figure in the political arena. Along with his father-in-law, Henry Gassaway Davis, Elkins founded Davis and Elkins College in West Virginia and was the secretary of war under Benjamin Harrison before becoming a U.S. senator from West Virginia. (Library of Congress.)

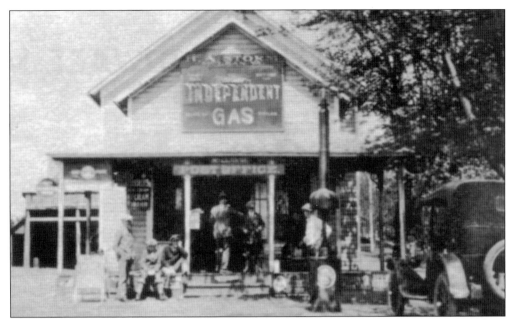

In April 1910, John Storm purchased property adjacent to the rail tracks at a foreclosure sale. It included a general store from which the McLean Post Office already operated. The building was razed and a new structure built on the foundations of the old one. Storm's son, Henry Alonzo "Lonnie" Storm, opened Storm's General Store and Post Office in June 1910. (*McLean Remembers.*)

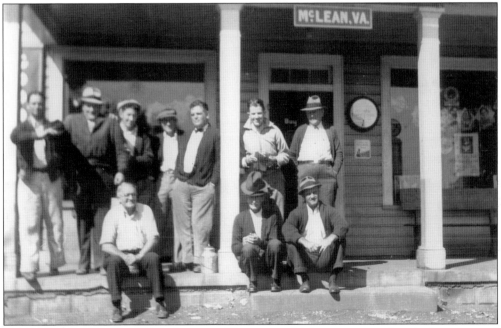

Storm's Store was not a railroad station. The stop at McLean was simply a little uncovered waiting area across from the general store, on the opposite side of the tracks, with a concrete slab floor. Storm's Store served the community as a general store, post office, space for meetings, and gathering place for local residents, as depicted in this 1934 photograph. (Fairfax County Public Library Photographic Archive.)

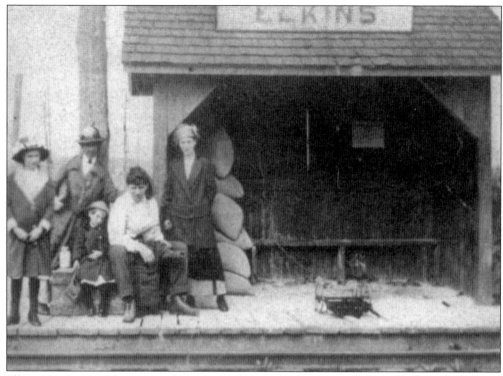

Elkins Station was the next-to-last stop before the trolley entered Great Falls Park. It was a rudimentary shelter, located where the tracks crossed Georgetown Pike, but was more substantial than the station at McLean. Farmers from nearby Forestville brought their dairy products to Elkins for shipping into the District and students rode the trolley to and from the Franklin Sherman School. (Great Falls Historical Society.)

The route of the electrified railroad ended at Great Falls Park; here the tracks looped around the terminal station so that the trolley was in position for the return trip back to Rosslyn. This 1908 photo shows Car No. 3 waiting for passengers at the Great Falls station, which was very substantial in comparison to some of the three-sided shelter "stations" along the line. (Great Falls Historical Society.)

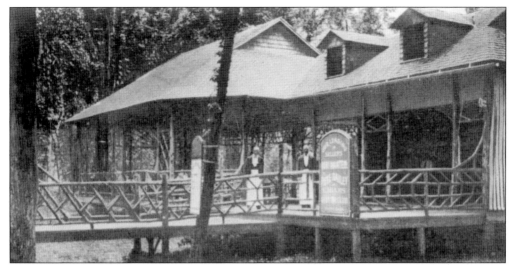

Besides the scenic beauty of the falls, Great Falls Park offered a dance pavilion, a picnic area, and a carousel. Carl and Isabella Blaubock opened the Great Falls Inn about the time the trolley began operating. It started out as a place where one could dine at tables with linen tablecloths and fresh flowers, and be served by waiters in dark jackets and bow ties. (Carolyn Cornwell Miller.)

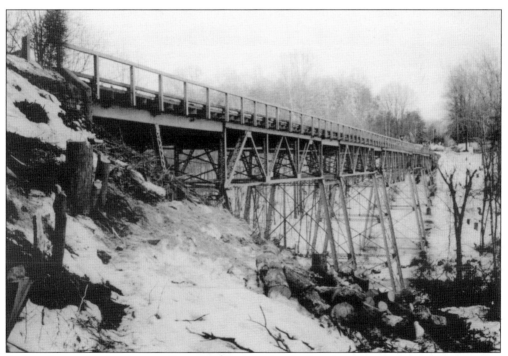

Service began for the Great Falls and Old Dominion Railroad on March 7, 1906, but the line stopped at Difficult Run. Getting across the Difficult Run valley was challenging. A 600-foot-long steel trestle and truss bridge was constructed to carry the cars 70 feet above the valley floor. The trolley made its first scheduled passenger arrival at Great Falls Park on July 4, 1906. (Great Falls Historical Society.)

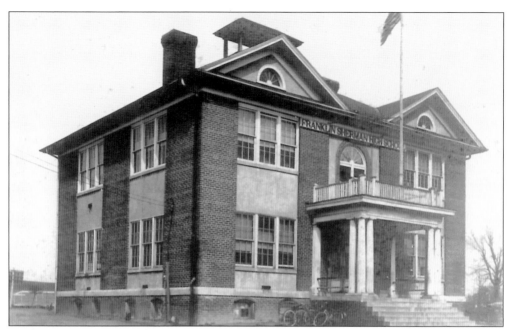

Fairfax County built a public school near the McLean stop facing what now is known as Corner Lane. The school was later named Franklin Sherman after a member of the Fairfax County School Board. The Franklin Sherman School was a consolidation of the Lewinsville, Langley, Springhill, and Chesterbrook one-room schools. It opened in 1914 with 29 students and Charlotte Troughton (Corner) as its first principal. (Carolyn Cornwell Miller.)

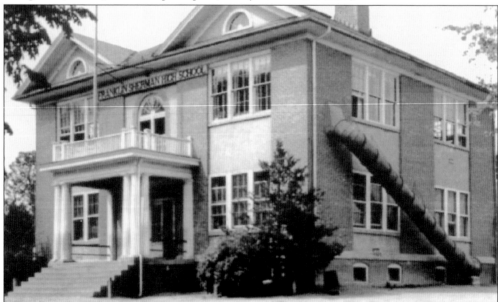

In 1927, the McLean Volunteer Fire Department recommended that a fire escape be added at the Franklin Sherman School. A metal tubular fire escape was attached to the outside of the southeast wall of the building and connected a second story classroom with the playground below. Students would play in the chute by climbing up inside and sliding down when no one was looking. (Carolyn Cornwell Miller.)

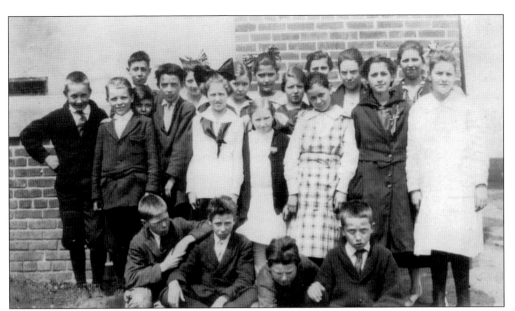

The above photo was taken at the Franklin Sherman School in April 1917 and may well be the entire high school student body. Pictured are, from left to right, (first row) John Cockrill, ? Grimes, Robert Stoy, and Glenn Smith; (second row) Baxter Smith, Niels Nielson, Floyd Gantt, Bessie Wells, Selma Faulkner, Hazel Money, Lois Hill, and Lois Furlong; (third row) Lancelot McIntosh, Adriene ?, Frances Wells, Estella Oliver, Marie Palmer, Eula Kirby, Eugenia Anderson, Edith Mack, and Marian Weekley. The lower 1920 photo shows the beginning of the area's growth by the increased enrollment at Franklin Sherman. Students of all grades are standing around the front steps of the school and the teachers and principal are standing on the balcony. (Carolyn Cornwell Miller.)

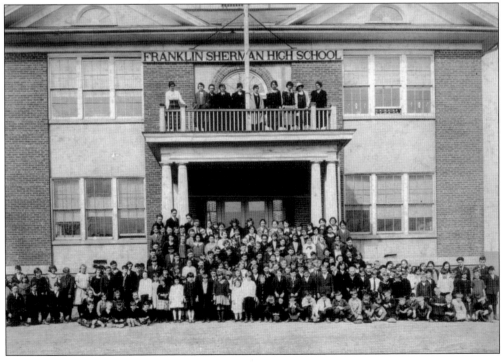

On June 6, 1923, the high school senior class that graduated from Franklin Sherman High School consisted of just six students. From left to right are (first row) Florence Phillips, Alyce Aniole, Annie Cornwell, and Dorothy Wickline. The two boys behind them are Alfred Leigh and George Cornwell. (Carolyn Cornwell Miller.)

e all love dear old McLean
e very best school of all
e is "our" alma mater"
ay she never fall
t keep on rising higher
til she finds the goal,
r which we have been striving
d has many times been told
(horus)
Lean, McLean, the school we
ds so dear,
e fight for what we get, the
ay is never clear
ates, success, is what we hope
'll gain,
d some day you will find
at,
t sure was worth the pain.
II

George Cornwell was part of the senior class that graduated from Franklin Sherman High School in 1923. He went on to become a well-known musician, composer of music, and poet who had weekly radio broadcasts over station WOL. Cornwell wrote words for a school song in which he refers to the Franklin Sherman School as "McLean." (Carolyn Cornwell Miller.)

Lydia Carper started a school in her home, Prospect Hill, about 1883. As enrollment increased, a one-room, white-framed schoolhouse was built on the north side of Georgetown Pike, near Spring Hill Road. Spring Hill School closed with the consolidation of area schools and many of the students then attended Franklin Sherman. In later years the volunteer firemen destroyed the building though a controlled fire as shown above. (Milburn Sanders.)

Baptists began meeting at the Spring Hill School in 1905. The McLean Baptist Church organized in 1917 and held services at the Franklin Sherman School. The congregation built a church (right) on Emerson Avenue, with the first service held in 1925. The Baptists later purchased three acres of the Salona farm for a church on Brawner Street, which was dedicated in 1954. (McLean & Great Falls Celebrate Virginia.)

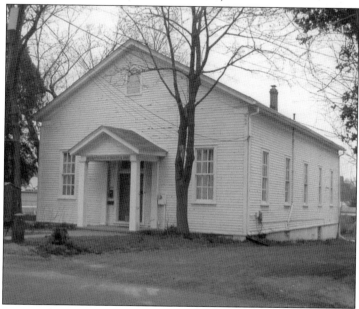

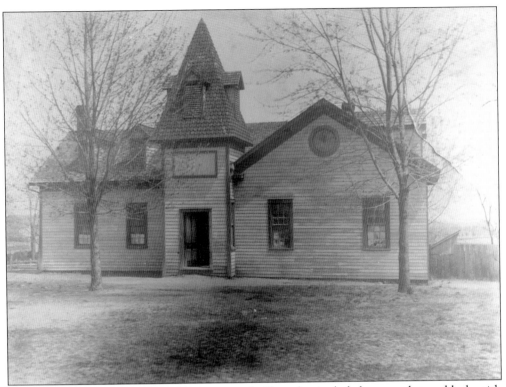

Lewinsville was a well-established, incorporated village that included a general store, blacksmith shop, church, post office, and school by the time the Great Falls and Old Dominion Railroad began operating. The above Lewinsville School closed with the opening of the Franklin Sherman School in McLean, and the Lewinsville students then attended the new school. (Fairfax County Public Library Photographic Archive.)

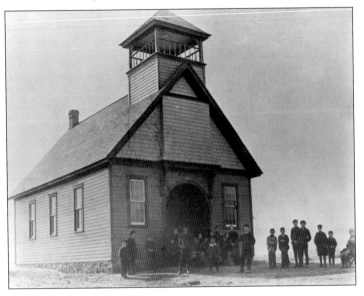

This *c.* 1900 picture shows the Langley School, which was located to the east of the Langley hamlet on Georgetown Pike. The building stood on a knoll on the south side of Georgetown Pike, near what became Potomac School Road. The Langley School closed with the consolidation of the area schools into the Franklin Sherman School. (Fairfax County Public Library Photographic Archive.)

In 1913, St. John's Catholic Church was constructed on Linway Terrace, at the El Nido stop. It was a mission of St. James Catholic Church in Falls Church and became a parish in 1951 with the appointment of the first pastor. The Church-in-the-Round was completed in 1956, with the original church (above) serving as the parish office and the St. John's Thrift Shop. (St. John's Catholic Church.)

Members of St. John's Episcopal Church believed that its congregation would increase if the church relocated from Langley to McLean to be near the rail stop. In 1914, the church building was physically mounted on casters and pulled through fields to a site on Chain Bridge Road. The Rectory, followed by the Parish Hall, was built after the relocation of the church. (St. John's Episcopal Church.)

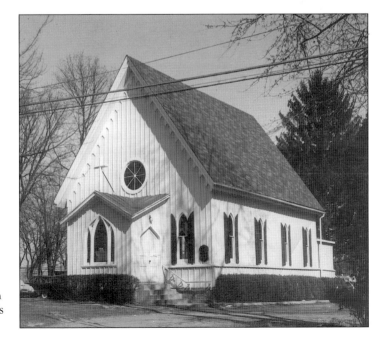

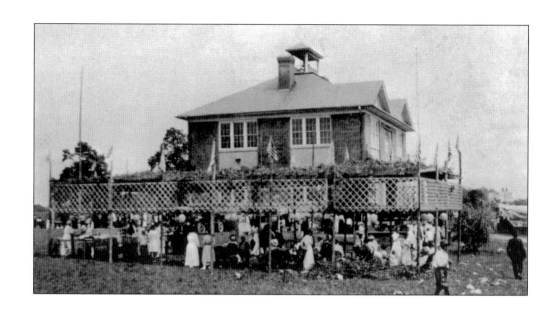

McLean's School and Civic League Inc. sponsored the first McLean Day in 1915, at the Civic League Lot adjacent to the Franklin Sherman School. Part of the proceeds went towards school improvements, such as a driveway for the front entrance, sidewalks, and better piping. McLean Day became an annual event, but in later years it was turned into a week-long celebration known as the McLean Carnival sponsored by the McLean Volunteer Fire Department. The event reverted back to a one-day festival in 1975 when the McLean Community Center began sponsoring McLean Day and holding activities at the Center. As attendance increased, the Center moved McLean Day to Lewinsville Park in 1988 and continues to sponsor the event on the third Saturday in May. Both photos show McLean Day in 1915. (*McLean Remembers.*)

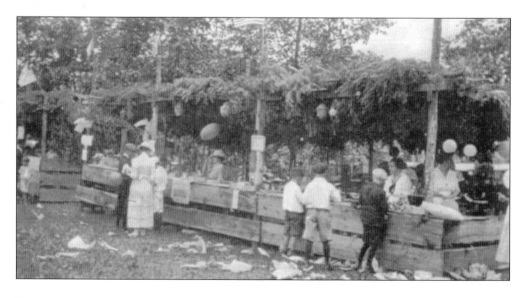

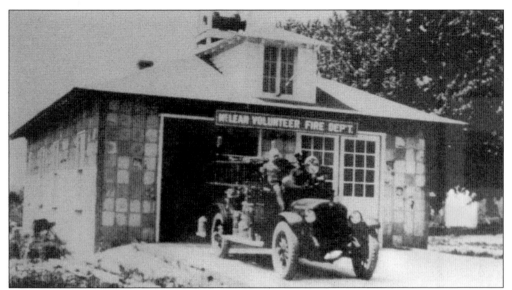

Meetings were held in Storm's Store around 1916 concerning a volunteer fire company. The McLean Volunteer Fire Department was incorporated in 1923 as Station No. 1 in Fairfax County. That same year James Beattie sold, for $10, one-sixth of an acre of his property at Cedar Street and Chain Bridge Road specifically for a firehouse; McLean's first fire station was completed in 1925. (McLean Volunteer Fire Department.)

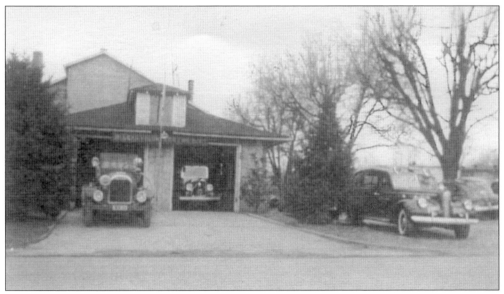

A large two-story attachment was added to the rear of the original one-story fire house in 1932. The cost for the new structure was minimal because all of the necessary materials were donated and the labor was provided by volunteers. The photo, taken in August 1942, shows the original fire station and a portion of the larger addition. (Helen Kidwell.)

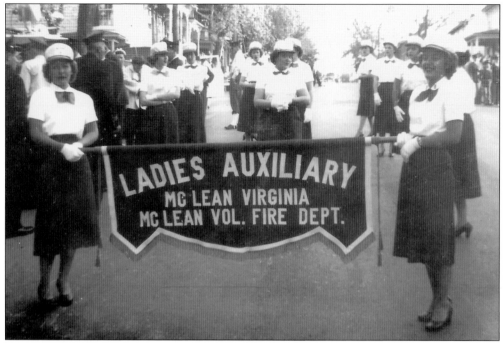

The McLean Volunteer Fire Department's Ladies Auxiliary organized in 1925, but reorganized in 1935 so that it could better support the station in its fund-raising efforts by holding bake sales, raffles, dinners, helping at the annual carnival, and providing refreshments for the firefighters during times of emergencies. The Ladies Auxiliary formed a Marching Unit and participated in parades throughout the area during the 1950s and 1960s. (Jack Akre.)

The Leiter House was built around 1912, above the Potomac Palisades. It was surrounded by more than 700 acres and consisted of 72 rooms, 17 bathrooms, and numerous fireplaces. About 1912 Joseph Leiter macadamized the Georgetown Turnpike from Chain Bridge to the entrance of his estate. Fairfax County reimbursed him and he never paid a toll. The mansion was destroyed by fire in the mid-1940s. (National Archives.)

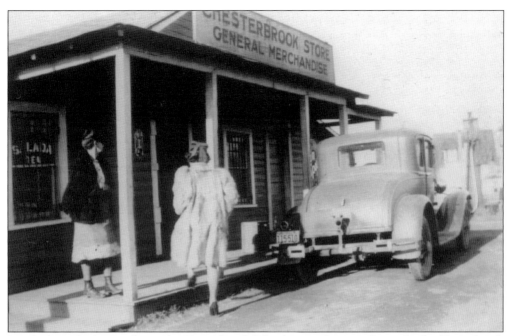

Inez Stalcup, the first teacher at the Chesterbrook School, opened a general store for the Chesterbrook community in 1909. It was located on the west side of Kirby Road, where the Sylvestery is today. Inez Stalcup is standing on the wooden porch and one of her daughters, Dorothy, is stepping onto the porch. (Peggy Stalcup Byers.)

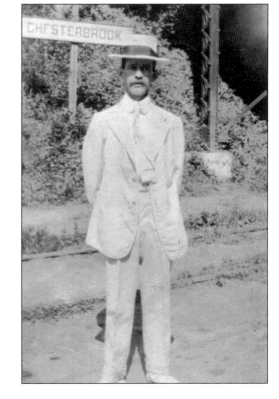

There were 39 stops along the route of the Great Falls and Old Dominion Railroad. Henry Harland Hill is shown here around 1930 waiting for the trolley at the Chesterboook stop where there is no shelter for cover. Behind him are the steel foundations that supported the bridge over the tracks at Kirby Road. (Janet Beall.)

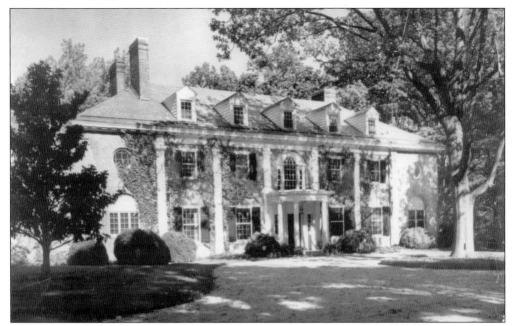

Merrywood was built around 1919 overlooking the Potomac Palisades. Newbold Noyes, the owner of the *Washington Star*, was the first to occupy the house. Hugh Auchincloss, the stepfather of Jacqueline Bouvier Kennedy, purchased the estate in 1927; it became Jacqueline's girlhood home. C. Wyatt and Nancy Dickerson acquired the house and seven surrounding acres in 1965; the remaining 40 acres were developed into luxury townhouses. (Jan Elvin.)

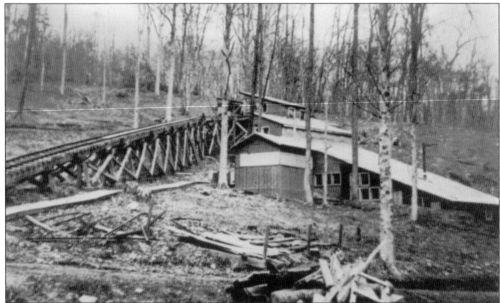

The Virginia Gold Mining and Milling Company opened the Bullneck Mine off the Potomac River in 1922. The following year the unprofitable mine closed and the property was sold. In 1934, the price of gold rose to $35 an ounce. The original owners repurchased the same land and, in 1936, formed Virginia Mines Inc. The new mine was also unprofitable and closed in 1940. (Fairfax County Public Library Photographic Archive.)

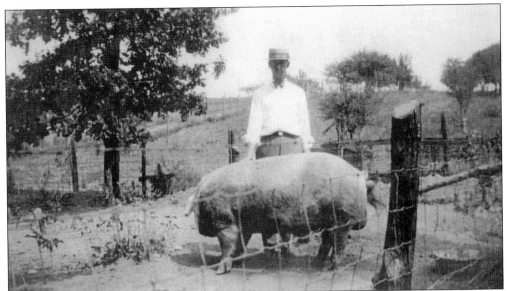

McLean was an agricultural community consisting of farms of various sizes. Farmers raised vegetables, fruits, chickens, turkeys, and dairy products for sale in the District markets. Some raised hogs and either butchered them for family use or took them to a stockyard where they were slaughtered. John Wheat had a farm on Balls Hill Road and is shown standing behind his prize 855-pound hog. (Willie Wheat.)

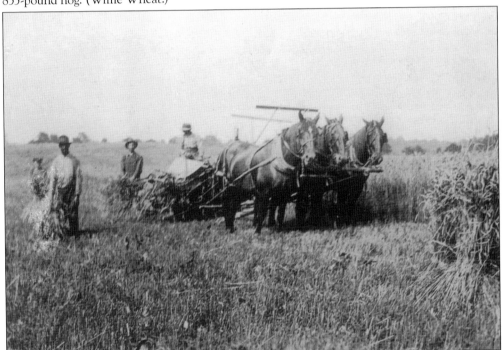

In this c. 1925 photo, hired hands are harvesting wheat on the farm of Marvin and Agnes Kirby, located on Chain Bridge Road in Langley, opposite today's CIA entrance. The horses are pulling a reaper, which gathers and cuts the stalks, and the hired hands are setting the stalks into shocks. (Joe Berry.)

This photo was taken at the farm of Ernest and Lavinia Kirby, located in the Chesterbrook community at Westmoreland Street and Kirby Road. There were several Kirby farms in the Chesterbrook area. This Kirby farm included property that was taken by eminent domain to build Longfellow Intermediate School. A townhouse development, known as Ambiance of McLean, was built later on the Kirbys' remaining land. (Shirley Kirby Crist.)

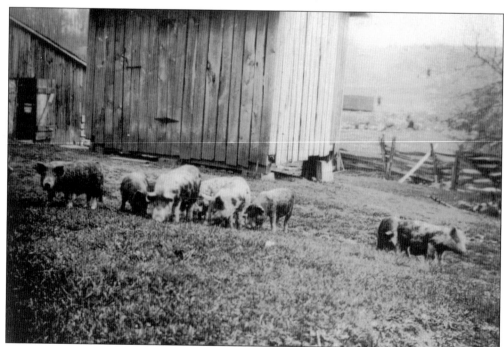

The pigs and hogs in this c. 1930 photo are busily eating in front of one of the many outbuildings on the Salona property. The estate operated at this time as a family farm, managed by Calder Gilliam Smoot. In 1932, the house was open to the general public for the first time in its history in observance of the anniversary of George Washington's bicentennial birthday. (Dariel Knauss VanWagoner.)

A windmill was built over a brick well in the front yard of dairy farmers Lew and Mary Magarity, who lived on Westmoreland Street. In 1976, it was painted red, white, and blue for America's bicentennial celebration. The windmill stood for years as a landmark reminiscent of a rural community called McLean that slowly faded into memory. It was taken down in 2003. (McLean & Great Falls Celebrate Virginia.)

This c. 1925 photo shows Julia Knauss with her first three children, Julia, Annabelle, and Norman "Buddy." The family lived where the McLean Community Center is today, but later moved to Marion Avenue. Buddy was killed on Chain Bridge Road while getting off a school bus. His death led to a law requiring that vehicles stop when children are getting on and off a school bus. (Sylvia Knauss Sterling.)

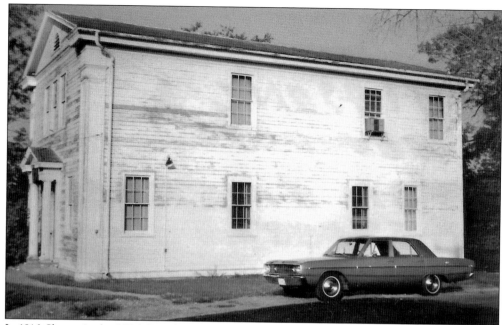

In 1916, Sharon Lodge 327 A.F. and A.M. was granted dispensation from the Grand Lodge of Virginia and began meeting in Storm's Store and the Franklin Sherman School. In 1921, its members built the above Sharon Lodge at the corner of Chain Bridge Road and Emerson Avenue. American Oil purchased the lodge site in 1972, and the building was razed in 1977. (Philip Graves.)

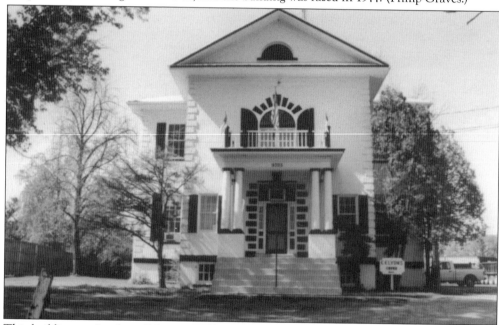

This building on Leesburg Pike originally served as a school. It was erected in the early 1920s on land donated by Harry Leigh that was part of his dairy farm. In the late 1940s E. E. Lyons purchased the property and the former schoolhouse was converted into an office and residence for his family. Today the building provides office space for Lyons Construction. (McLean & Great Falls Celebrate Virginia.)

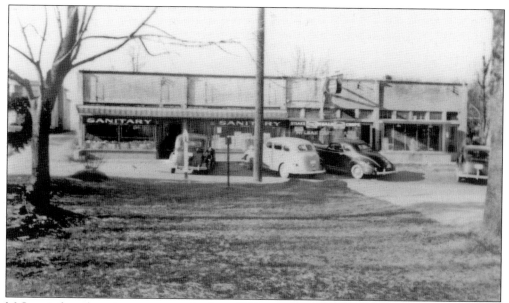

McLean's first shopping center was built in 1925, on Chain Bridge Road between the William Laughlin house and the fire station. This 1942 photo shows the center with the Sanitary Grocery Store (which housed Doc Jones' Drug Store at that time), the McLean Restaurant, and an empty unit that had been damaged by fire. (Helen Kidwell.)

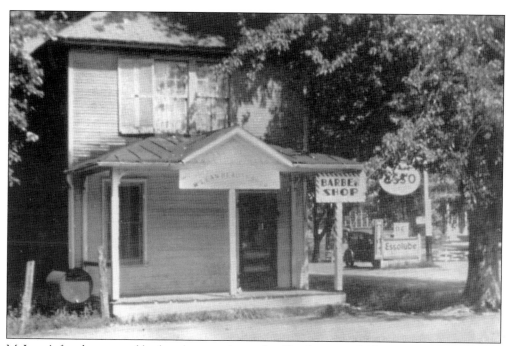

McLean's first beauty and barber shop was located at Elm Street and Chain Bridge Road, facing Elm Street. In the background is Chain Bridge Road, the Esso sign for Carper's service station, and the fence along the grounds of the Franklin Sherman School. (Fairfax County Public Library Photographic Archive.)

In the early 1920s Frank Walters started a housing development called Walter Heights. He contracted with Sears, Roebuck and Co. to build their prefabricated houses. About one third of Walter Heights consisted of Sears houses that were built along Buchanan Street and Marion Avenue. The Norman Knauss family lived in the above Verona style Sears house, located at Chain Bridge Road and Marion Avenue. (Dariel Knauss VanWagoner.)

Each prepackaged Sears house arrived by rail and was unloaded at the siding by Storm's Store. Everything was then hauled to the property site, where the home was assembled. Each house came with a Certificate of Guarantee which stated that every home would be exactly as represented and sufficient materials would be provided to complete the house according to the plans. (Philip Graves.)

The above prefabricated Sears house arrived by the Great Falls and Old Dominion Railroad and was put together on Marion Avenue in 1926 for the Warren Graves family, whose son Philip continues to reside in the house today. The two-story house (not a Sears house) in the background faces Waverly Way and was later occupied by the Hollinger family. (Philip Graves.)

This *c.* 1935 photo was taken from Marion Avenue, looking toward King Street (now Melrose Avenue). The two men, Clay White on the left and Warren Graves Sr. on the right, are not dressed for sledding, but appear to be enjoying themselves. Philip Graves is in the box sled and on the right are Warren Graves Jr. and an unidentified friend. (Philip Graves.)

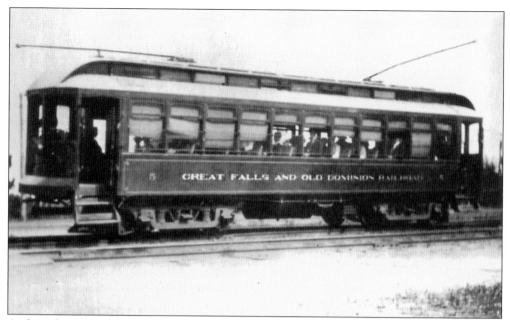

At first, the Great Falls and Old Dominion Railroad was financially successful. However, shifts in travel habits after World War I resulted in declining passenger and commercial traffic. Many people began driving automobiles, and trucks began hauling agricultural and milk products into the District markets. Combined with mismanagement and an unreliable schedule, the Great Falls and Old Dominion Railroad ceased operating on June 8, 1934. (*Rails to the Blue Ridge.*)

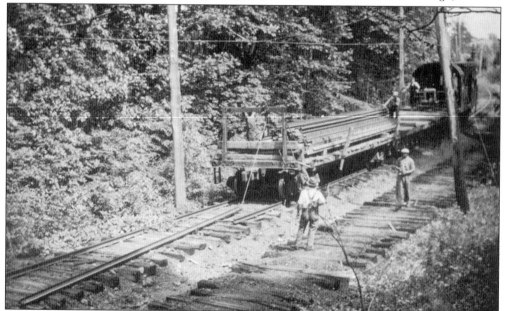

This 1935 photograph shows a crew removing the tracks of the abandoned Great Falls and Old Dominion Railroad line west of the Vanderwerken stop. The rail line provided a perfect right-of-way for a road through the developing areas of Arlington and Fairfax Counties; and so, the rail bed was replaced with asphalt and named Old Dominion Drive as a memorial to the former trolley line. (*Rails to the Blue Ridge.*)

The McLean Carnival was held as a fund-raiser for the McLean Volunteer Fire Department and the proceeds went towards supporting the fire department. This was a week-long event held on the Civil League Lot adjacent to the Franklin Sherman School. Ralph "Eppe" Pearson took both of these 1934 photographs of the entrance and exit archway billboard signs for the McLean Carnival. The entrance photo (top) includes a tree-lined Chain Bridge Road and St. John's Episcopal Parish Hall. The lower photo is the exit from the Civic League Lot, looking towards McLean. The pictured automobile that is partially hidden by the sign is sitting at today's Corner Lane and Chain Bridge Road. (Fairfax County Public Library Photographic Archive.)

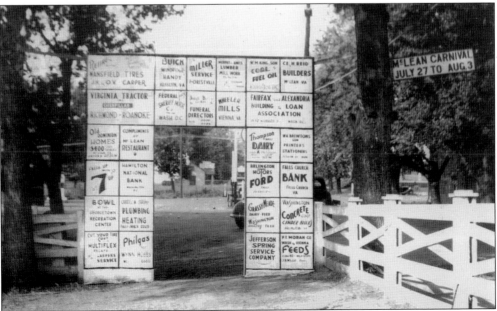

A barn-like structure was built along Old Dominion Drive in the early 1930s by cousins John and O. V. Carper to house equipment for their road construction business. They also owned and operated an Esso filling station in front of the barn that faced Chain Bridge Road. The filling station was diagonally across the road from Storm's General Store and Post Office. (Helen Kidwell.)

This 1939 picture shows Old Dominion Drive, just southeast of Carper's garage. By this time the trolley had ceased operating and its tracks had been removed, but Old Dominion Drive had not yet been paved. The two buildings shown remain today, but, during the 1950s, a two-story structure was constructed between them: McLean's first bank, Vienna Trust, on the lower level; a rooming house above it. (Helen Kidwell.)

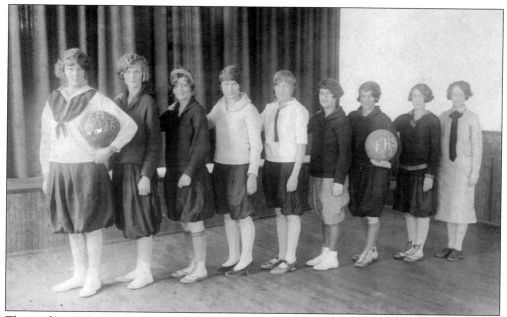

This is the 1926 girls' basketball team of McLean's Franklin Sherman High School. What an assortment of clothing for uniforms! Not everyone is wearing appropriate athletic shoes for the photo as shown by Elizabeth Pearson, fourth from left, who is wearing heels. From left to right are Mildred Jenkins, Gladys Robertson, Dot Follin, Elizabeth Pearson, Maggie Beach, Louise Ball, Thelma Morris, Ruby ?, and Coach Libby Hillsman. (Camella Rae Kilgore.)

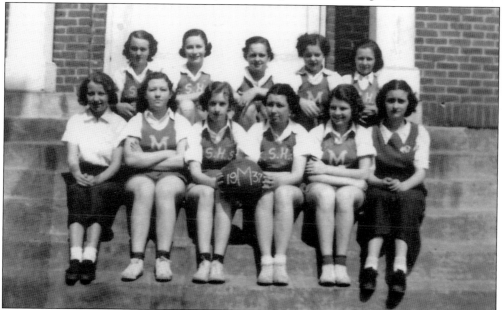

Fairfax High School opened in 1935 in Fairfax City. Franklin Sherman students spent the first two years of high school in McLean until 1939, while the juniors and seniors attended school in Fairfax City. The two-year high school segment at Franklin Sherman was often called McLean High. This photo shows the 1937 McLean High School girls' basketball team with their coach, Nancy Hailey. (Florence Money Gaghan.)

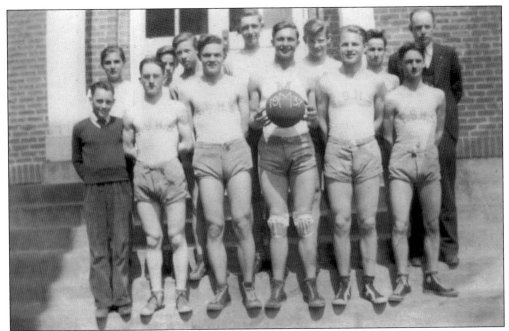

This photo shows the 1937 boys' basketball team that represented the two year segment of Franklin Sherman High School, sometimes called McLean High. The players are unidentified, but the coach, William S. Lawson, is standing in the back row to the far right. The team captains were not elected by the students, but were appointed for each game by the coach. (Florence Money Gaghan.)

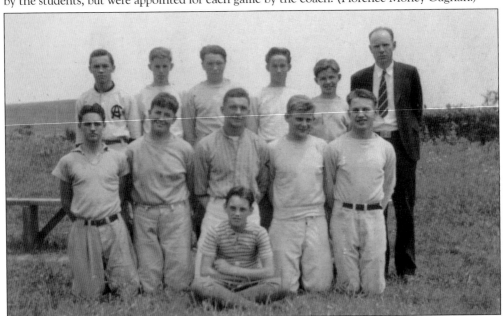

McLean High School (Franklin Sherman High School) also had a baseball team. This photo shows the 1937 McLean High baseball team with William S. Lawson, who served the school at various times as a teacher, principal, and coach of the team sports for boys. Some of the high schools the team played against were Herndon, Forestville, Falls Church, Fairfax, and Lee-Jackson. (Florence Money Gaghan.)

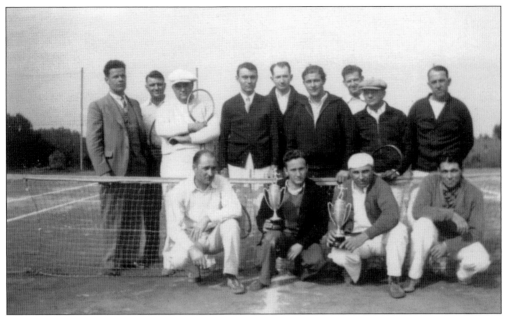

By 1930 Walter Heights was a well established neighborhood. Many of the men worked to organize the Walter Heights Tennis Club. They built a tennis court and stone fireplace on property owned, at that time, by Frank Gicker. Tennis tournaments were held in men's singles and doubles. Shown here is a pre–World War II photograph of some members of the Walter Heights Tennis Club. (Philip Graves.)

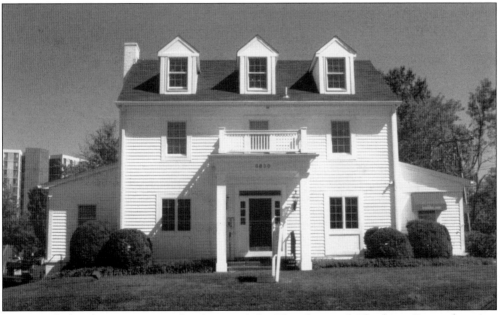

Due to a faulty chimney, a 1934 fire destroyed the Theodore and Charlotte Corner house at Elm and Poplar Streets. Shown is the house the Corners later built. Poplar lost its name to an extension of Beverly Road when Mackall's Hill was topped for constructing apartment buildings and business offices. The Corner house stands today, no longer as a residence, but for commercial use. (McLean & Great Falls Celebrate Virginia.)

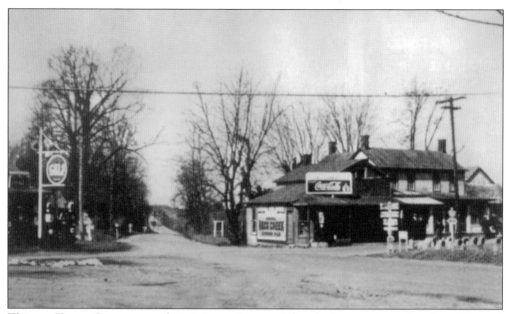

This was Tysons Corner around 1940. Myers Store stood at the intersection of Leesburg Pike and Chain Bridge Road. Leesburg Pike runs horizontally across the photo. The white directional road signs point right to Leesburg and straight ahead down Chain Bridge Road to Vienna. The store was originally part of a farm owned by William Tyson, for whom the intersection was named. (Fairfax County Public Library Photographic Archive.)

John "Willie" Day purchased a school bus and drove the Vienna route. He traveled down Leesburg Pike to Tysons Corner, where he dropped off a few elementary students for bus driver Lew Magarity to transport to the Franklin Sherman School. Day then continued picking up students and, after taking the younger ones to the Vienna Elementary School, continued to Oakton High where he dropped off the high school students. (Paul Day.)

Sixth

GROWTH

McLean's growth was slow, but a spirited community developed around the general store, volunteer fire department, and public school; there was a civic association, library, and several churches. It was not until after World War II, when many who came to Washington, D.C. to support the war effort decided to stay, that McLean's rural lifestyle started to change. Combined with the CIA locating at Langley in 1961, a steady increase in population began and McLean found itself in the midst of phenomenal growth.

Thomas Lee's 1719 grant makes up a large portion of the eastern side of today's McLean. The CIA, the Potomac School, Langley High School, the McLean Baptist Church, the historic Langley Fork District, Safeway, Franklin Sherman Elementary School, Hickory Hill, Salona, Rokeby, and Merrywood (the girlhood home of Jacqueline Bouvier Kennedy Onassis), are located on portions of the original grant. The western side of McLean developed on 3,402 acres granted to George Turberville from Thomas, Sixth Lord Fairfax, in 1724. This tract was called Woodberry Hill. The Langley Shopping Center, the Giant Shopping Center, the Balls Hill Police Station, the Lewinsville Presbyterian Church and adjoining cemetery, Benvenue, Churchill Road School, Cooper Intermediate School, Dolley Madison Library, and the McLean Community Center were built on former Turberville property.

McLean never became a separate town or city. It lost any opportunity to incorporate when, in 1968, Fairfax County adopted an urban county form of government. Today the windmills, farms, and orchards are gone. Notable dairy farms such as Maplewood, Sharon, Storm, and Kenilworth have been replaced with subdivisions and homes on a grand scale. Yet the community spirit and rural flavor of the area has remained; however, one has to wonder about the future of McLean, which is overshadowed today with the urbanization and continual expansion of Tysons Corner and new Metrorail service. Will the village of McLean go the way of Lewinsville or Langley? Hopefully this will not be the case and the community will not lose its identity or get "gobbled up" in the enthusiasm of progress.

To support the McLean Volunteer Fire Department, a McLean Horse Show was held on the grounds of the Ballantrae estate, owned by Harry Newman. The show received wide attention in 1943 when a leading magazine named it the "most beautiful horse show in Virginia." The above photograph was taken in 1944 when World War II was in high gear. (Julie Merrell Harris.)

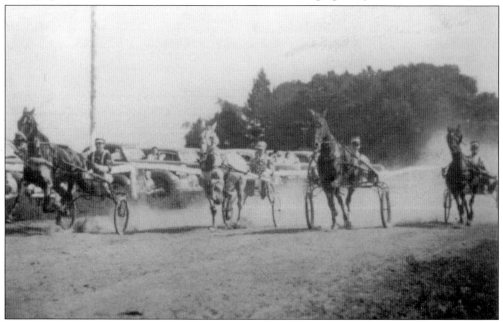

Paul and Vessie Rhinehart leased a large piece of property on the east side of Langley where they built a race track just off Georgetown Pike. Local horse races were often held there. The Rhineharts also trained and rented out horses and offered riding lessons. Shown above is a sulky race on the Rhinehart track that consisted of four Rhinehart drivers. (Annabelle Knauss Rhinehart.)

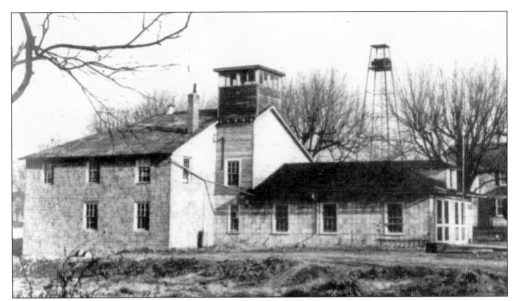

An airplane observation tower was added to the McLean Firehouse about 1943 so that local volunteers could watch the skies and identify possible enemy aircraft. There were always at least two persons on duty. They kept a log book and, if an airplane was spotted, it was immediately reported to the command center. This photo shows the original station, the addition, observation tower, and siren. (McLean Volunteer Fire Department.)

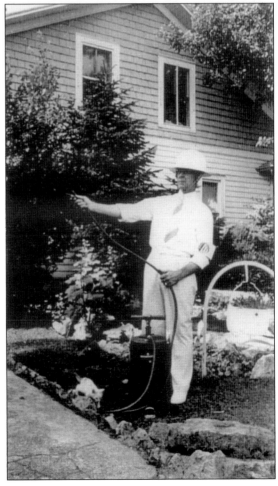

Blackout drills were held during World War II. Automobile headlights were turned off and blackout draperies were put over windows. A warden, who wore a helmet and carried a small fire pump to put out flames if bombs fell, made certain that no light was showing. John Wheat is shown wearing his warden's helmet and arm band as he demonstrates the proper use of a fire extinguisher. (Willie Wheat.)

During World War II, three members of the same McLean family were on leave at the same time. This photo of Robert, Charles, and John Kadel was taken in 1942 in front of their family house on Kirby Road about halfway between Westmoreland and Great Falls Streets. In the background is the Walter Kirby farm, also located on Kirby Road. (Gary Heath.)

Elaine Strawser (Cherry) and Joan Boland are standing with their bicycles on Kirby Road in front of Guy Beall's house about 1942. Linway Terrace is in the background and the white house to their left belonged to Carl MacIntosh and his wife, Jessie. Carl MacIntosh was the first police chief in Fairfax County. (Janet Beall.)

International photographer Del Ankers took the above photograph of rescue vehicles in front of the McLean fire station around 1943. It has been given the name "Parade Rest." Shown are a 1939 La Salle ambulance, a 1931 Brockway Pumper, a 1939 Chevrolet water tanker, and a 1935 Peter Pirsh Pumper. Chain Bridge Road runs through the middle of the picture. (McLean Volunteer Fire Department.)

The cinder-block firehouse and the large addition were taken down in 1947 and replaced with a one-story brick building with four engine bays on the same parcel of land. A hose tower was later added. The Giant Shopping Center was constructed in 1959 and can be seen in the background of this 1963 photograph. (McLean Volunteer Fire Department.)

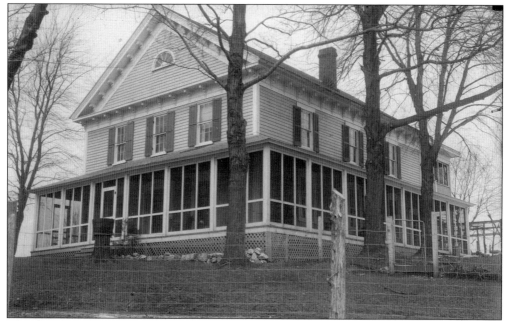

The above structure was built on Georgetown Pike by Methodists in 1858. Services were held there until 1893 when the Methodists built a second church, now the Langley Friends Meeting House. About 1900 Douglass Mackall purchased the original church and converted it into a house. The house was later transformed into the Happy Hill School, and today it is occupied by Country Day School. (Fairfax County Public Library Photographic Archive.)

During the 1950s, the Virginia National Guard operated a 120 mm antiaircraft gun site at Langley. This was never a Nike missile site; they came to Fairfax County in 1956. After the Army and National Guard operations and the gun site closed at Langley, the CIA built its complex at that location. This photo shows a National Guard tower at the Langley National Guard site in 1956. (Ann Hennings.)

Ray Gilpatrick built Killoran on Old Dominion Drive in 1945. The house was situated on 12 acres that had been part of the Kenilworth Dairy Farm. The Dominican Sisters of Saint Catherine de Ricci purchased the 12-acre property in 1961 and built the Dominican Retreat House, the first retreat house for women in Virginia. Killoran was converted into a convent for the residing Sisters. (Ray Gilpatrick.)

This 1945 photograph shows riders on horseback traveling down Balls Hill Road in front of Emma and Leonard Nordlie's house and reflects the still rural nature of the community. The Nordlie home was a Sears, Roebuck and Co. house, which was taken by the commonwealth in 1956 through eminent domain for the construction of the Capital Beltway (Interstate 495) off-ramp at Georgetown Pike. (Peter Nordlie.)

Margaret "Peg" Grant was a teacher of Swedish descent at the Franklin Sherman School. A writer for a Swedish newspaper discovered that she was teaching Swedish to her fifth grade students and came to McLean, took pictures, and wrote an article for a Stockholm newspaper that was printed May 3, 1947. This photo depicts Grant teaching Swedish to her class. (Jacqueline Grant Friedheim.)

Near Library Street, crossing guard Edna Kelly, wearing her official uniform, is assisting student crossing guard patrols in stopping traffic to help Franklin Sherman students safely cross what was then a rural two-lane Chain Bridge Road. Edna Kelly was the first school crossing guard in McLean; Library Street was later renamed Curran Street. (Fairfax County Public Library Photographic Archive.)

In 1915, the McLean Community Library, which had been housed at Salona, was moved into a second-floor room at the Franklin Sherman School. It remained there until Capt. Harry and Marie Abell loaned land on Library Street (now Curran Street) to build a community library. This 1947 photograph shows the sign at the corner of Library Street and Chain Bridge Road that directed one to the library. (Ann Hennings.)

The Dolley Madison Library, shown above, opened on Elm Street in 1956 with Elizabeth Williams as its first librarian. It was the fourth branch of the Fairfax County Public Library system. The building contained 5,558 volumes, 1,302 individuals used a library card, and 20,653 books were checked out the first year. The spelling on the outside sign was later corrected to include the "e" in Dolley. (Dolley Madison Library.)

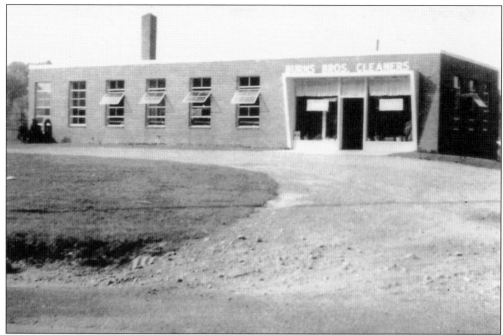

Burns Brothers Cleaners was the first dry cleaners in McLean. It opened in 1949 and operated from a free-standing building that faced Old Dominion Drive. Over time more businesses were added, and a complex developed that became known as the McLean Center. Of interest in the photo is the unpaved, semicircular driveway that connects with Old Dominion Drive. (Don Burns.)

Schmidt's Restaurant and adjoining Kuhn's service station were located on property beside today's Old Chain Bridge Road near Old McLean Village Drive. The original road led to Reid's Bend, located at the present site of Old Chain Bridge Road and Dolley Madison Boulevard. The restaurant was a favorite "watering hole" for many local residents. (Chuck Rieger.)

The McLean Summer Theater, under the direction of coproducers Tommy Brent and Jim Garwood, was a popular attraction during the summers of 1950, 1951, and 1952. Performances were presented by the "Straw Hat Players," a youthful acting company with experience in the theaters of New York, and were held at the St. John's Episcopal Parish Hall. Frank MacIntosh, one of the actors and a radio and early television personality, is standing beside the billboard in this 1950 photo. The actors resided at Salona, unoccupied at that time, but still owned by the Smoot family. McLean residents often provided props and costumes for the plays, and area youth served as ushers and helped with set construction. The Arnold Bus Line ran a special that left from Eleventh and E Streets in the District and took people to and from the performances. Two of the players, Frances Stemhagen and George Grizzard, went on to have successful careers in New York and Hollywood. (Sylvia Knauss Sterling.)

Clive and Susan DuVal purchased the first of three tracts of the Salona property from Smoot heirs in 1953 and renovated the house before moving in. Lacking descriptions of the original dwelling, they attempted to preserve as much as possible of what they believed to be the original house, while adapting it for modern use. This c. 1935 photo shows Salona many years before its restoration. (Dariel Knauss VanWagoner.)

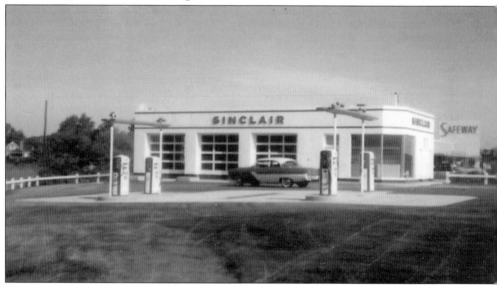

Safeway's first McLean location was at Elm Street and Chain Bridge Road. When it relocated to its present site, residents protested against a huge sign the company erected in front of the store. After lengthy negotiations, citizens convinced Safeway to display a less intrusive sign. This 1956 photo shows Jerry Hennings's service station and his 1955 Plymouth Belvedere with the controversial Safeway sign in the background. (Ann Hennings.)

In spite of heavy opposition, particularly from radio broadcaster Walter Winchell, field trials began in McLean as part of a nationwide test of a new polio vaccine. Dr. Richard Mulvaney administered the first shots of the Salk vaccine in the United States to first graders at the Franklin Sherman Elementary School on April 26, 1954. (March of Dimes.)

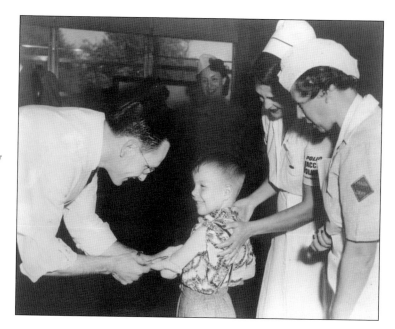

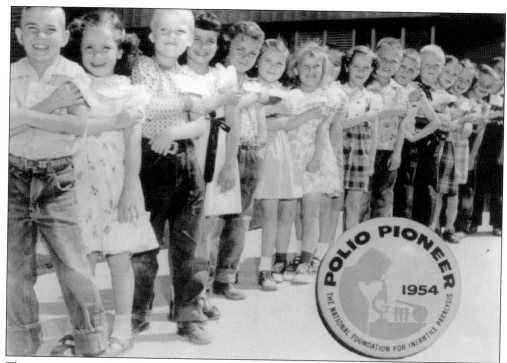

The way to prove the effectiveness of Dr. Jonas Salk's polio vaccine was to test it on humans. Parents who agreed to have their children participate in the program took a calculated risk. This photo shows first graders at Franklin Sherman Elementary School lined up to receive the nation's first polio shots. This was the first step in eliminating a crippling disease that often led to paralysis. (March of Dimes.)

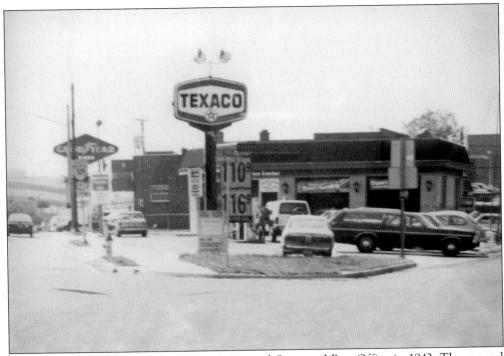

Henry A. "Lonnie" Storm closed Storm's General Store and Post Office in 1942. The general store was replaced with a District Grocery Store that was ordinarily referred to as a DGS and was operated by Hilda and Izzy Katz for over 15 years. The DGS was taken down in 1960 and replaced by the Texaco station shown above. (Merrily Pearce.)

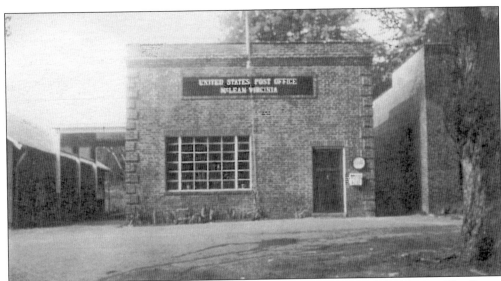

With Storm's Store closing, the McLean Post Office relocated into a brick building on Elm Street. "Lonnie" Storm continued as postmaster until retiring in 1951; Basil Gantt took over as acting postmaster. The McLean Post Office later moved into the McLean Center on Old Dominion Drive (the flag pole is still there), and then relocated to its present site on Elm Street in 1962. (Fairfax County Public Library Photographic Archive.)

Mary Sanders Trammell is sledding on Trammell property near Churchill Road around 1947 with her daughter Mary Jo. Bright Carper's large dairy farm, Sharon, is behind the fence in the background. Mary's brother-in-law, French Trammell, operated a dairy farm consisting of about 50 acres that ran from the fence up to Balls Hill Road. Mary and her husband Joseph Trammell lived on Elm Street, but often visited the farm. (Robert Stoy.)

Before residential swimming pools, community swim clubs, and the Spring Hill Recreation Center came into vogue, area residents swam or cooled off in tributaries of the Potomac River. Annabelle Knauss Rhinehart is shown about 1950 with two of her three children. They are swimming in a popular swimming hole at that time, along Difficult Run near her home. (Annabelle Knauss Rhinehart.)

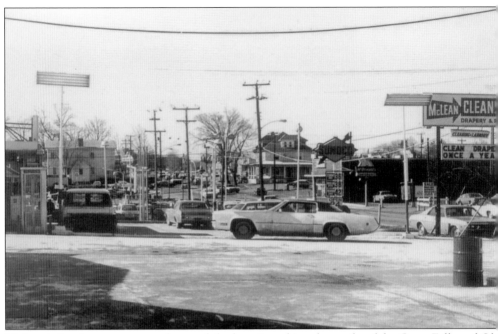

McLean's development centered around the location where the tracks of the Great Falls and Old Dominion Railroad crossed Chain Bridge Road, a major transportation artery through Fairfax County. After the demise of the trolley, the tracks were removed, and the roadbed of the rail line became Old Dominion Drive. These two photos were taken from Chain Bridge Road, facing Old Dominion Drive, on opposite sides of the intersection. The top 1973 photo includes the "Blue House," the Sharon Masonic Temple, and a phone booth on the left. Gasoline at the Sunoco station was 36.9¢ a gallon. St. John's Episcopal Parish Hall and the original Franklin Sherman School building are seen in the background of the lower photograph. (Above, Ann Hennings; below, Fairfax County Public Library Photographic Archive.)

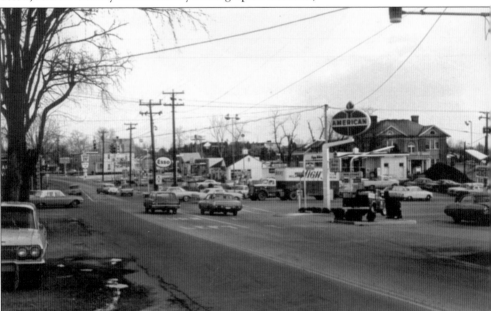

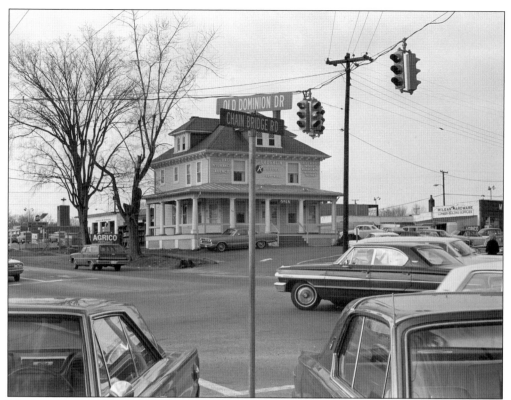

The Laughlin House, often referred to as the "Blue House," was at the southwest corner of Chain Bridge Road and Old Dominion Drive. The redbrick PNC bank building is now on that site. The above photo is misleading. The directional road sign has been turned around so that the streets are incorrectly identified. (Fairfax County Public Library Photographic Archive.)

McLean was slow to change until the early 1960s, as indicated by this 1959 photograph taken in front of the Laughlin House (not shown). The car has stopped for the traffic light at the intersection of Chain Bridge Road and Old Dominion Drive. Carper's Garage and Esso station is diagonally across the intersection from the Laughlin House; an Exxon station occupies that site today. (Fairfax County Public Library Photographic Archive.)

McDonald's selected a site on Elm Street for one of its fast food restaurants and opened on December 12, 1961. At that time a hamburger cost 15¢, French fries were 12¢, and a milk shake was 20¢; a person could have a complete meal for 47¢. The single arch in front posted how many hamburgers had been sold nationwide. The arch in the above 1966 photo shows that over three billion had been sold. The single arch was one of the few remaining in the nation when the Elm Street McDonald's closed and the arch was taken down on April 30, 2010. The brick building on the right was the location of the first Safeway in McLean. (Above, Fairfax County Public Library Photographic Archive; below, McLean & Great Falls Celebrate Virginia.)

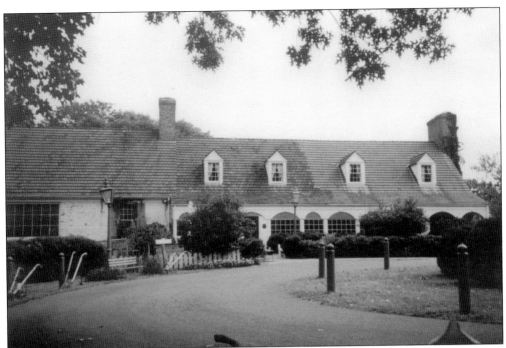

Evans Farm Inn opened in 1959. This was a colonial style restaurant where one dined on plantation fare presented by servers in period costumes. It was not historic, but using antiques and materials from prominent places, plus farm animals for the public to view, created an 18th-century atmosphere. Evans Farm was sold for development and the Inn officially closed December 31, 1999. (Steve Sommovigo.)

In 1961, the first employees reported for work at the campus-like CIA headquarters at its new location in McLean adjacent to the Federal Highway Administration. This was a consolidation of more than 20 office buildings scattered throughout Washington, D.C. Pres. Dwight D. Eisenhower presided at the laying of the CIA cornerstone at the ceremony in 1959. (Fairfax County Office of Planning and Zoning.)

The McLean Bowling Center was owned and operated by Mark and Annabelle Rhinehart. It opened on Old Chain Bridge Road about 1960 and was immediately a popular place for community recreation; there were leagues and teams. This photograph shows a team of five women who bowled in the Happy Housewives league. (Annabelle Knauss Rhinehart.)

Shown here is the June 9, 1956, opening day of the Chesterbrook Little League with Dale Williams the chief umpire. There were 11 teams that first season; the diamond was behind the Chesterbrook Presbyterian Church on Westmoreland Street. In 1958, the name changed to Chesterbrook-McLean Little League. Land was purchased in 1959 further west on Westmoreland Street and parents built four diamonds in time for the 1960 season. (McLean Community Center.)

The "Half A House" was under construction on Beverly Road when plans were finalized to build a new highway through McLean. The Virginia Department of Highways cut the house in half for the construction of Dolley Madison Boulevard. Half of the house was left standing for a long time, as shown, before being taken down. (Shirley Alexander.)

Woodside Estates is part of the former dairy farm of Elizabeth and Granville Berry, who donated 5 acres of their land for a man-made lake and 2 acres for a small park. Woodside Lake was built in 1953. Later, men of the Woodside Lake Association constructed a dock, seawall, and rafts, and stocked the lake with fish. This photo shows ice skating on Woodside Lake in 1965. (Richard Morningstar.)

The 1950s witnessed the beginning of area farmers selling their property for subdivisions of single family homes and commercial establishments. The landscape was barren, with a limited number of small trees. Several residents planted trees to add ambiance to the community. Two such individuals were Bob Andrews and Clive DuVal 2d, who are shown in front of the A&P Grocery store (today McLean Hardware) on Chain Bridge Road. (Corkie Kirkham.)

As a part of the McLean Citizens Association, the McLean Trees Committee was organized in 1980 with Richard Poole as its chairman. Its members collected newspapers and magazines at Cooper Intermediate School on Saturday mornings for recycling, and the proceeds financed planting and maintaining trees and shrubs throughout McLean. Poole is in the middle of the trio, standing on a recycling bin accepting newspapers. (McLean & Great Falls Celebrate Virginia.)

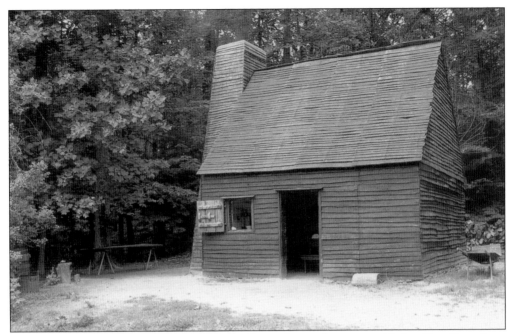

In 1973, the National Park Service opened a "living history" project at Turkey Run Farm, later named Claude Moore Colonial Farm. This replica log cabin was built as part of the program to portray the life of an average family living on a small tenant farm during colonial times. Claude Moore Colonial Farm is the only privately operated national park in the United States. (Claude Moore Colonial Farm.)

In the late 1960s, upon petition of the citizens to the Fairfax County Board of Supervisors, a special taxing district was approved to help fund a community center in McLean. In 1970, district citizens passed a bond referendum for center construction, which began in 1974 at Ingleside and Oak Ridge Avenues. The McLean Community Center opened in 1975 with the Robert Ames Theatre and four multipurpose rooms. (McLean Community Center.)

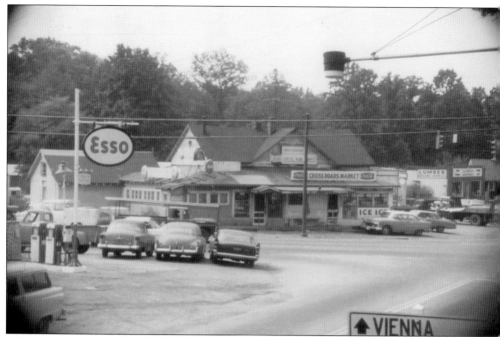

This 1963 photo shows the intersection of Chain Bridge Road and Leesburg Pike (Virginia Route 7), known as Tysons Crossroads. The Crossroads Market with an adjoining restaurant was at the southwest corner of Chain Bridge Road and Leesburg Pike, across from the Esso filling station and garage. The arrow points down Chain Bridge Road to Vienna. (John Watson.)

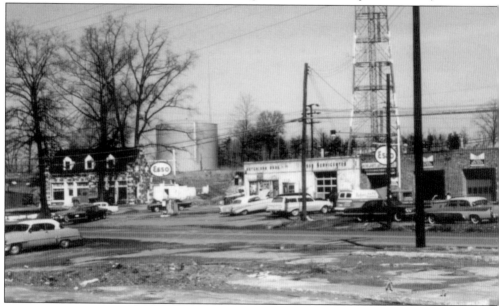

Shown is Leesburg Pike at Chain Bridge Road in 1963. Chain Bridge Road ran between the stone service station and Esso filling station and garage at that time, but was later redesigned to run parallel to the water tower on top of the knoll. The Esso site was once a garage and automobile dealership owned by John and Albert Watson. The water tank and communications tower remain today. (John Watson.)

This photo is of Della Storm, whose brother Henry Alonzo Storm owned and operated Storm's General Store. Della married Harry Farver. They lived in a large house on a hill adjacent to the Franklin Sherman School overlooking the trolley tracks. They had a tennis court and let everyone use it without asking. The Hamptons of McLean townhouse development was later built on their property. (Bob Koenig.)

In 1978, a *Life* magazine photographer spotted a fire at the former residence of Della and Harry Farver. He thought it incongruous that a fireman would be purchasing something at the vegetable stand while a house was engulfed in flames; he stopped and took this picture. What he did not realize was that the fire was a training exercise for local volunteer and paid firefighters. (Dolley Madison Library.)

Veterans of Foreign Wars Post 8241 purchased property in 1969 on Spring Hill Road that included a farmhouse; the house was used as a clubhouse until their hall was built in 1981. The Civil War cannons in front of the building came from Arlington Cemetery and were cast by the Washington Navy Yard. (McLean & Great Falls Celebrate Virginia.)

American Legion Post 270 was established in 1946 with a post home on Balls Hill Road for local war veterans who served in the armed forces. Post 270 also included McLean Unit 270 of the American Legion Auxiliary, which was composed of mothers, wives, sisters, and daughters of eligible veterans. Its many citrus sales raise funds to support numerous community programs and activities. (McLean & Great Falls Celebrate Virginia.)

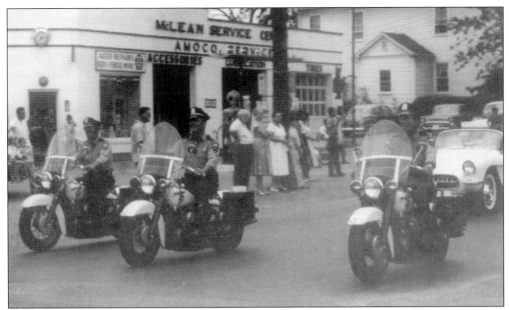

The McLean Service Center stood at the corner of Chain Bridge Road and Old Dominion Drive when Fairfax County police led the above parade down Chain Bridge Road. Today a BP Station occupies that spot, and the McLean Service Center is located on Chain Bridge Road across from the Langley Shopping Center. In the background is the Sharon Masonic Temple, which later relocated to Balls Hill Road. (Vito Pappano.)

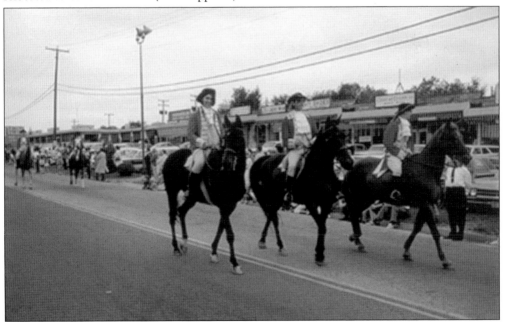

This 1967 parade is traveling down Chain Bridge Road in front of the Salona Village Shopping Center, which opened in 1955 with four stores and was completed in 1958. The center was owned by four members of the Smoot family: Julia Smoot and her three children, Jack, Henry, and Jane. The center's physical appearance has remained about the same over time, but many of the retailers have changed. (Sam Neel.)

The McLean Settlers Clan Reunion, which was a gathering of early McLean residents and their descendents, was held at the Claude Moore Colonial Farm in 1990. Three individuals who attended the one-day event of more than 1,000 people were Douglass and Henry Mackall and their stepsister Julie Merrell Harris, shown at left. (Julie Merrell Harris.)

During a morning rush hour in 1993, a lone gunman, Mir Aimal Kansi, exited his car and began indiscriminately firing an automatic rifle into vehicles waiting to turn left into the CIA. Two CIA employees were killed and three others wounded. A memorial to honor the victims was built in the median of Dolley Madison Boulevard where the shooting spree took place. (McLean & Great Falls Celebrate Virginia.)

The McLean Community Center took over the operation of McLean Day and began holding a one-day event on its grounds in 1976. Attendance became more than the Center's facilities could handle and McLean Day was moved to Lewinsville Park, still under the sponsorship of the community center. Dressed in top hat and tails is Tommy Lukas, who served as master of ceremonies for years. (McLean & Great Falls Celebrate Virginia.)

Much of the 1861 Battle of Lewinsville took place on the grounds of Lewinsville Park. Looking at soccer fields, tennis courts, and baseball diamonds, it is easy to forget that lives were lost on property now used for recreation. The c. 1854 farmhouse remains, but is blocked from view in this photograph by the stage set up for McLean Day activities. (McLean & Great Falls Celebrate Virginia.)

As McLean grew, more demands were placed upon the fire department to accommodate area needs. A site was purchased one block away from the existing firehouse and, in March 1988, a larger station opened at Whittier and Laughlin Avenues with sufficient career personnel on duty 24 hours a day to staff an engine, ladder truck, heavy duty rescue squad, and medic unit. (McLean & Great Falls Celebrate Virginia.)

Fairfax County acquired the four-bay fire station when the fire department relocated to Whittier and Laughlin Avenues. The county retained the older structure by turning it over to the McLean Community Center, which transformed it into a teen center, known as The Old Firehouse. Shown is the grand opening of The Old Firehouse in 1990. (McLean Community Center.)

In 1965, the Fairfax County Park Authority acquired 25 acres of land along Dead Run stream at Dolley Madison Boulevard and Old Dominion Drive. Their purpose was to establish a Central Park and McLean Green. The dedication ceremonies were held on August 22, 1965. A "tot park" and gazebo were later added. Many community activities are held in the park, including summer concerts as shown above. (McLean Community Center.)

The McLean Farmer's Market opened in 1981 at the McLean Baptist Church. Vendors sold fresh produce, cut flowers, potted plants, baked goods, honey, cider, and eggs. The market relocated to Lewinsville Park in 1998, where it operates under the jurisdiction of the Fairfax County Park Authority. Merchants continue to sell the same homegrown products, except for eggs, because animal products are now prohibited. (McLean & Great Falls Celebrate Virginia.)

In 1961, Betty and Lester Cooke purchased the miller's house and gristmill site, once owned by Edward and Frances Swink. Betty was a leader in saving the Burling Tract (Scott's Run Nature Preserve), and getting Georgetown Pike designated a "Virginia Byway." A bridge over Scott's Run was named in her honor. The historic miller's house has remained unoccupied since Betty's death in 1999. (McLean & Great Falls Celebrate Virginia.)

Adele Lebowitz gave 18 acres of land in front of her home to Fairfax County for Clemyjontri Park, a playground designed for disabled and able-bodied children. The park, which opened on Georgetown Pike in November 2006, includes a carousel and picnic pavilion. The Clemyjontri name was derived from her four children; Carolyn (CL), Emily (EMY), John (JON), and Petrina (TRI). (McLean & Great Falls Celebrate Virginia.)

McLean celebrated its 100th anniversary in June 2010. The "McLean Centennial Celebration" was sponsored by McLean & Great Falls Celebrate Virginia and held at the McLean Community Center. The honorary chair was former Virginia governor and U. S. senator Charles Robb, and the master-of-ceremonies was former state delegate Vince Callahan. A logo for McLean, designed by artist Eric Hottenstein, was presented to the community in an opening ceremony, and recollections were collected by filming over 30 speakers who discussed life in early McLean. Memorabilia was on display, plus a 40-foot-long poster illustrating the route of the Great Falls and Old Dominion Railroad. The commemoration included a presentation by McLean & Great Falls Celebrate Virginia of 64 photographs of early McLean to the community center for a permanent exhibit; it is the largest such collection in Fairfax County. Attendees entered the community center by walking under the above archway billboard sign, a recreation of the 1934 billboard entrance to the McLean Carnival featured on page 89. Standing under the sign are Ken Lenherr, Randy Dyer, and Tom Wedertz. (McLean & Great Falls Celebrate Virginia.)

www.arcadiapublishing.com

Discover books about the town where you grew up, the cities where your friends and families live, the town where your parents met, or even that retirement spot you've been dreaming about. Our Web site provides history lovers with exclusive deals, advanced notification about new titles, e-mail alerts of author events, and much more.

MADE IN THE **USA**

Arcadia Publishing, the leading local history publisher in the United States, is committed to making history accessible and meaningful through publishing books that celebrate and preserve the heritage of America's people and places. Consistent with our mission to preserve history on a local level, this book was printed in South Carolina on American-made paper and manufactured entirely in the United States.

This book carries the accredited Forest Stewardship Council (FSC) label and is printed on 100 percent FSC-certified paper. Products carrying the FSC label are independently certified to assure consumers that they come from forests that are managed to meet the social, economic, and ecological needs of present and future generations.

FSC
Mixed Sources
Product group from well-managed
forests and other controlled sources

Cert no. SW-COC-001530
www.fsc.org
© 1996 Forest Stewardship Council

Find Your Place in History.